Cambridge Ontario Part 1: Galt in Photos Book 2, Saving Our History One Photo at a Time

Photography
by Barbara Raué
2013

Series Name:
Cruising Ontario

Book 39: Galt Book 2

Cover photo: Spruce Street – cobblestone architecture
– 1½ storey Gothic Revival, cornice brackets,
bay window topped with triangular pediment

Series Name: Cruising Ontario

Book 1: London
Book 2: Dundas
Book 3: Hamilton
Book 4: Oakville
Book 5: Chesley
Book 6: Stoney Creek
Book 7: Waterdown
Book 8: Owen Sound
Book 9: Mount Forest
Book 10: Dundalk
Book 11: Burford
Book 12: Waterford
Book 13: Drumbo
Book 14: Sheffield
Book 15: Tavistock
Book 16: Ancaster and Mount Hope
Book 17: Innerkip
Book 18: Brantford
Book 19: Burlington
Book 20: Guelph
Book 21: Ayr
Book 22: Erin
Book 23: Goderich
Book 24: Lucknow
Book 25: Paris
Book 26: Toronto
Book 27: Beaver Valley
Book 28: Collingwood
Book 29: Peterborough
Book 30: Orangeville Beginnings Part 1
Book 31: Orangeville Part 2 and Area
Book 32: Port Elgin
Book 33: Southampton
Book 34: Jarvis
Book 35: Hagersville
Book 36: Caledonia
Book 37: Simcoe
Book 38: Galt Book 1
Book 39: Galt Book 2
Book 40: Preston
Book 41: Hespeler
Book 42: Kitchener
Book 43: Waterloo
Book 44: Shelburne
Book 45: Alton

Other Books by Barbara Raue

Coins of Gold

Arrows, Indians and Love

The Life and Times of Barbara
Volume 1: Inventions That Have Enhanced My Life
Volume 2: Entertainment That I Have Enjoyed
Volume 3: East Coast Trips
Volume 4: Olympics Have Always Intrigued Me
Volume 5: Wonders of the World
Volume 6: Caribbean Cruises We Have Enjoyed
Volume 7: Animals
Volume 8: Storms and Other Major Disasters in My Lifetime
Volume 9: Wars, Terrorist Attacks and Major Disasters

The Cromwell Family Book

Visit Barbara's website to view all of her books
http://barbararaue.ericraue.com

Galt

In 1784 the British Crown granted to the Six Nations Indians, in perpetuity, all the land along the Grand River six miles deep on each side of the river from its source to Lake Erie. The Indians, led by Joseph Brant, had the land surveyed in 1791 and divided into Indian Reserve lands as well as large tracts which they intended to sell to land developers. One such developer was the Honourable William Dickson who, in 1816, came into sole possession of 90,000 acres of land along the Grand River which later made up North and South Dumfries Townships.

It was Mr. Dickson's intention to divide the land into smaller lots to sell to the Scottish settlers that he hoped to attract to Canada. For the town site, the place where Mill Creek flows into the Grand River was chosen and in 1816 the settlement of Shade's Mills began. When the Post Office opened in 1825, the new name of Galt was chosen for the town in honour of the Scottish novelist and Commissioner of the Canada Company, John Galt.

In its early days Galt was an agricultural community serving the needs of the farmers in the surrounding countryside. By the late 1830s, the settlement began to develop industrially and acquired the reputation for quality products that in later years earned the town the nickname "The Manchester of Canada".

In the late 1960s the provincial government began looking at ways in which municipal governments could become more effective. On January 1, 1973, the City of Galt was amalgamated with the towns of Preston and Hespeler to form a single city, the new city being called Cambridge.

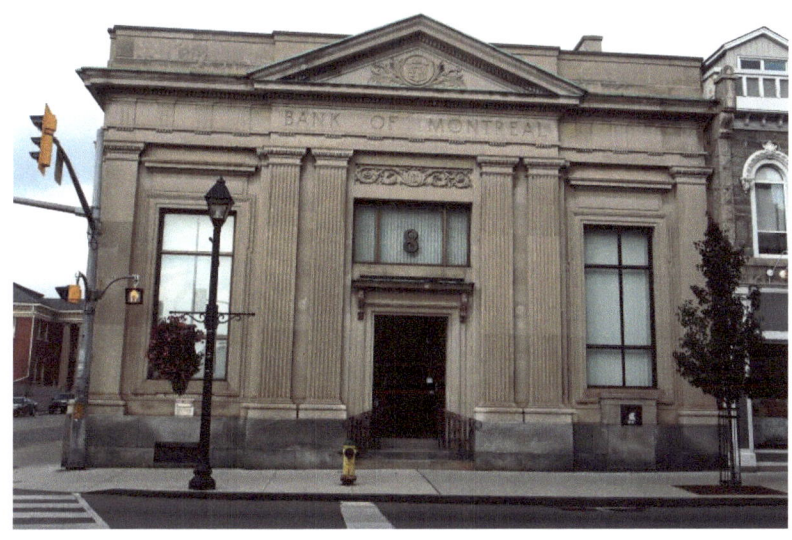

Bank of Montreal – Main Street – Italianate style, pediment with decorative tympanum

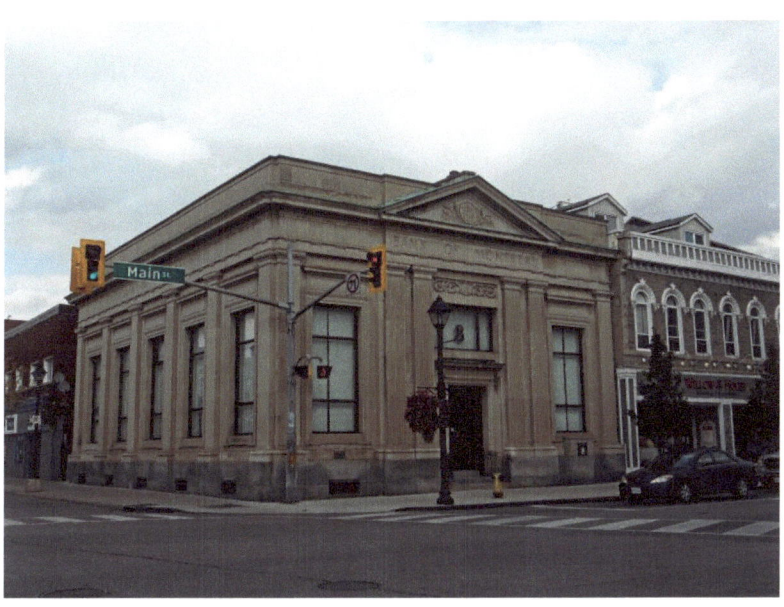

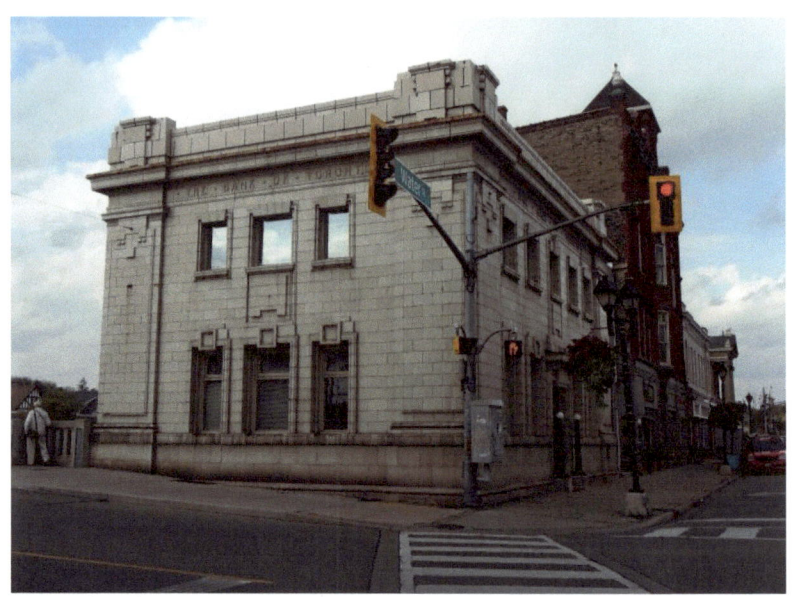
Bank of Toronto – corner of Main and Water Streets

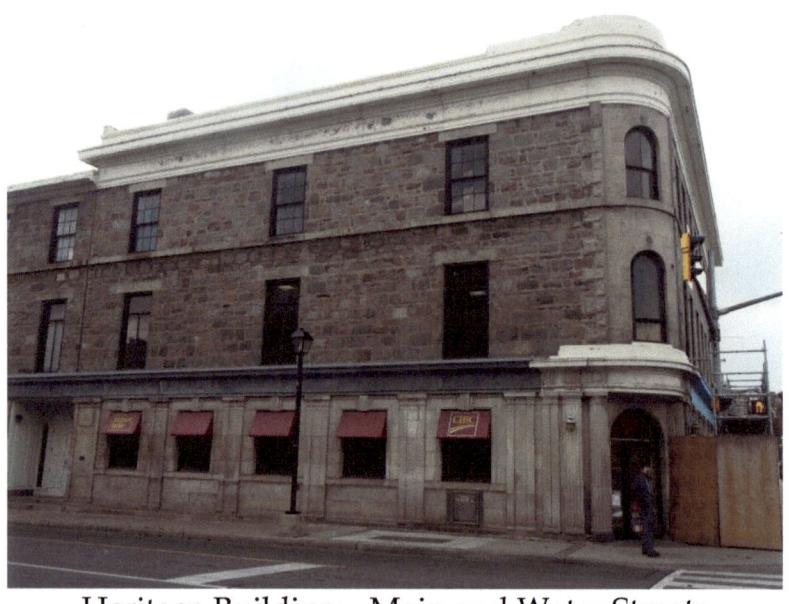
Heritage Building – Main and Water Streets

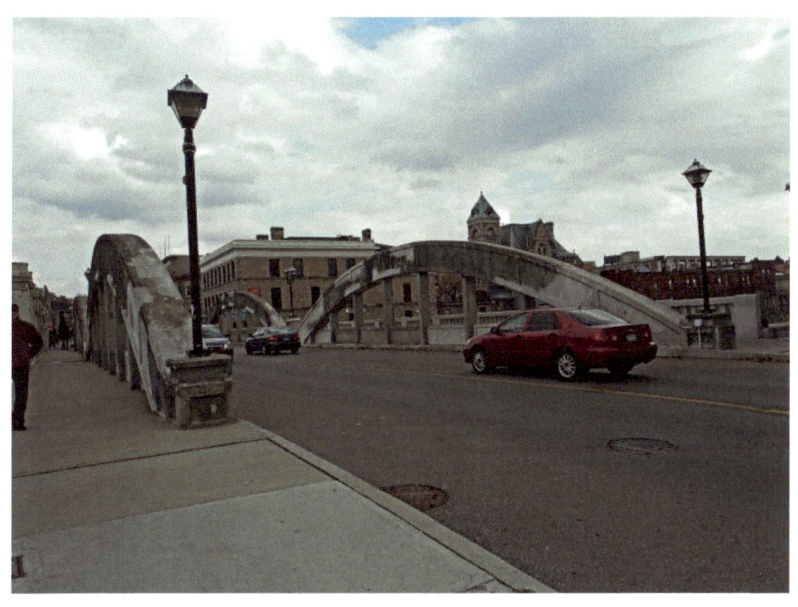

Main Street Bridge

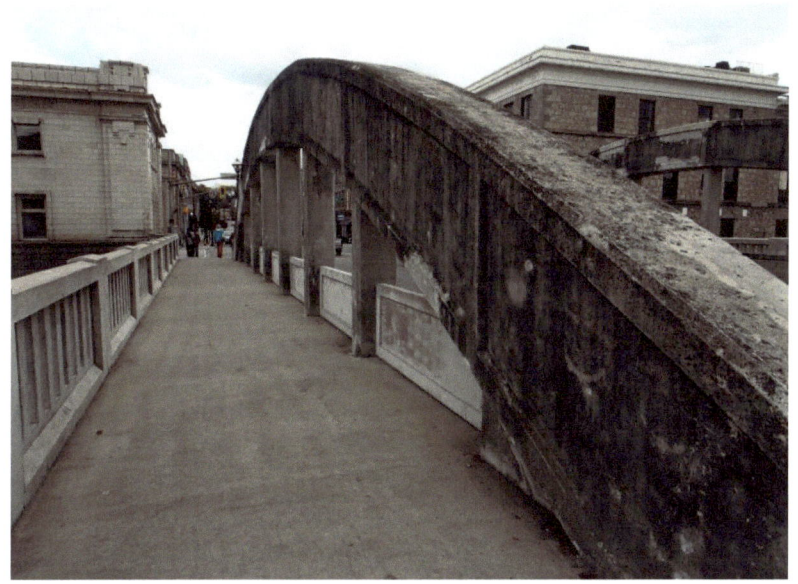

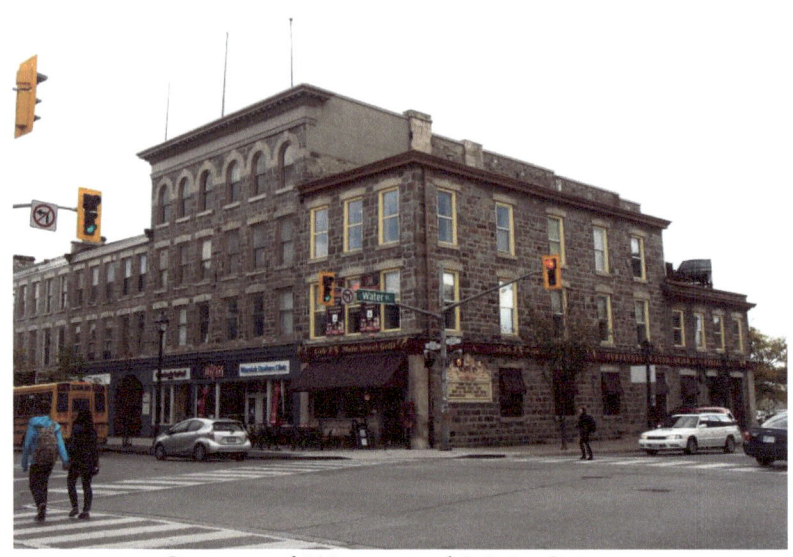

Corner of Water and Main Streets

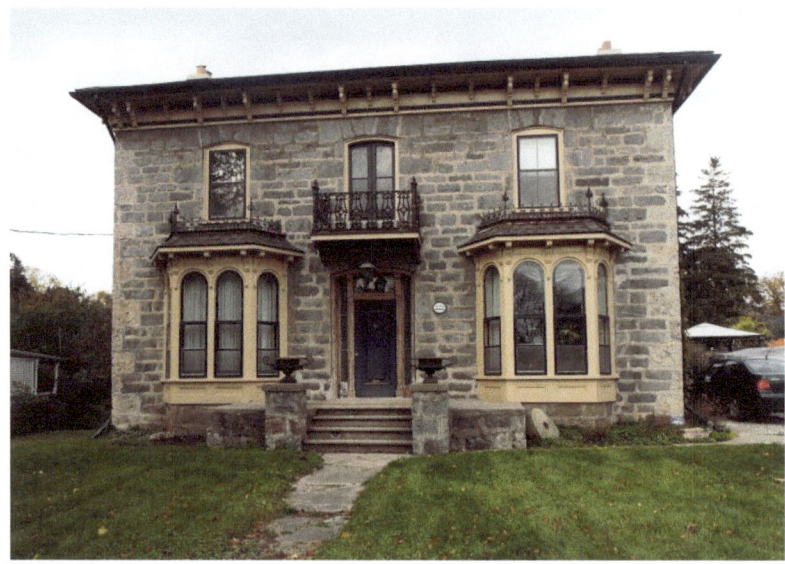

222 Main Street – Italianate – cornice brackets, iron cresting above bay windows and around 2nd floor balcony, cornice brackets, hipped roof

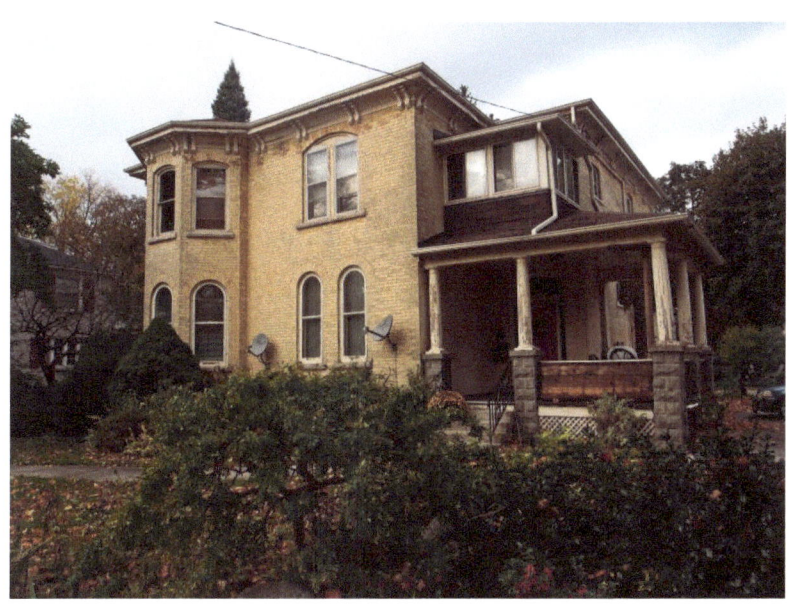

216 Main Street – Italianate style, cornice brackets, two-storey bay window

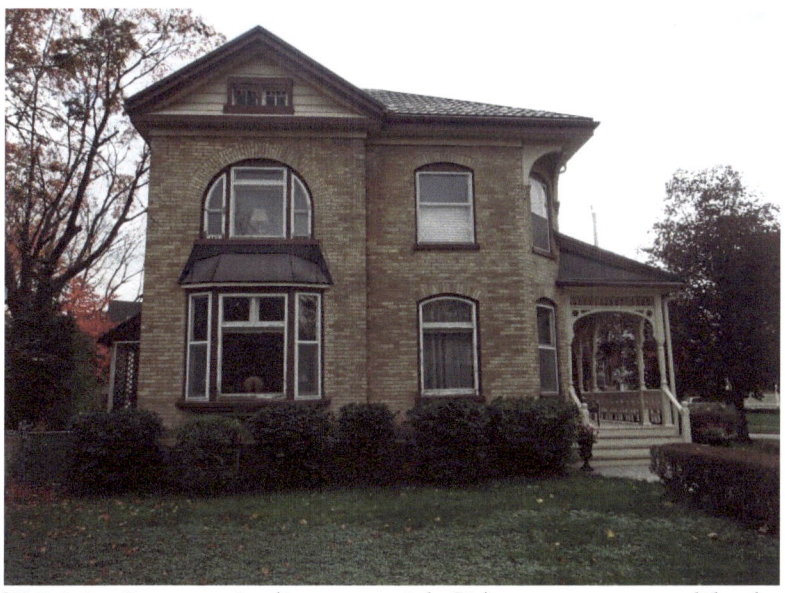

205 Main Street – Italianate with 2½ storey tower-like bay

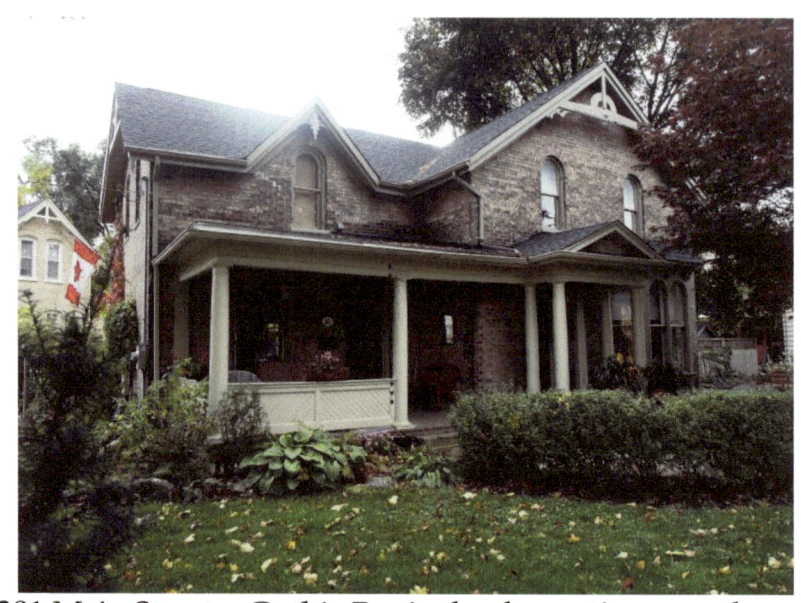

201 Main Street – Gothic Revival – decorative vergeboard

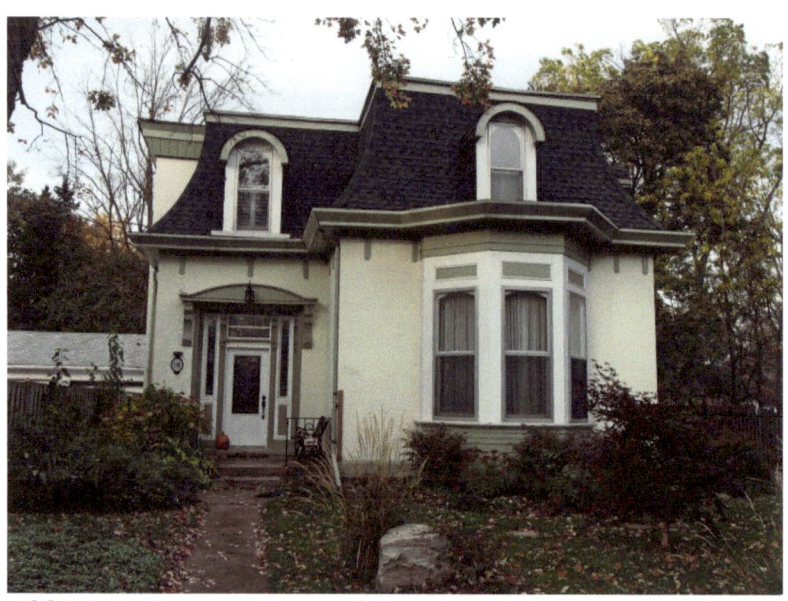

198 Main Street – Second Empire style – mansard roof

Old barn – cobblestone construction on lower level

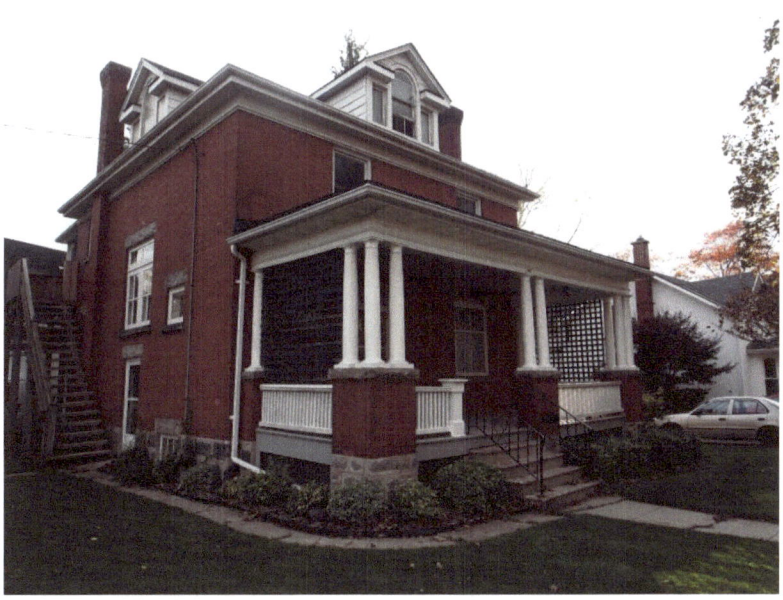

Main Street – Italianate with dormers in attic

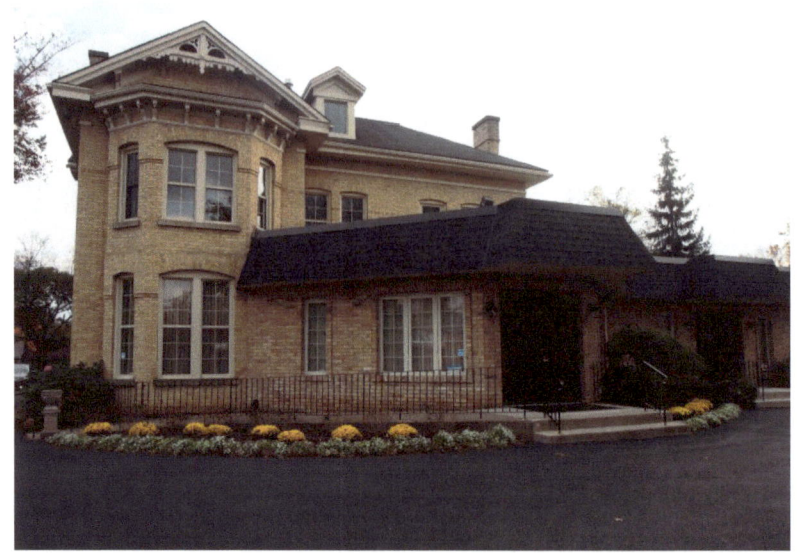

223 Main Street - T. Little Funeral Home – Italianate with two-storey tower-like bay with triangular pediment with vergeboard trim on gable, cornice brackets, dormer in attic

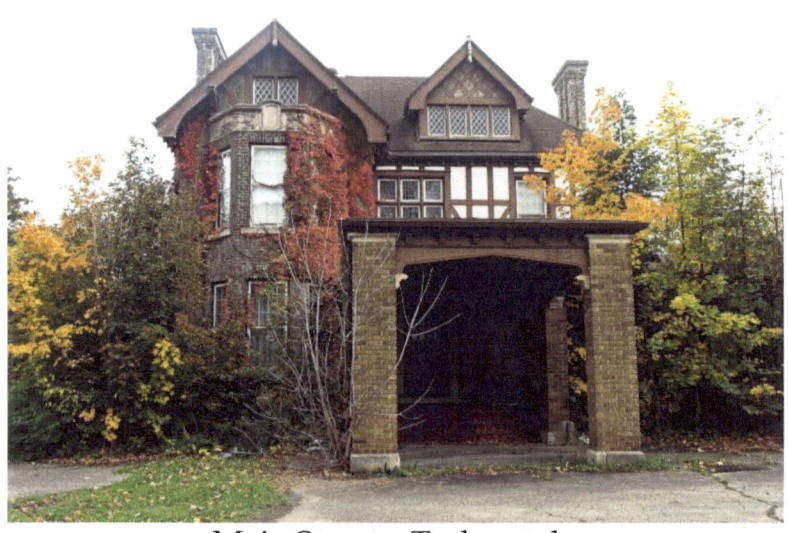

Main Street – Tudor style

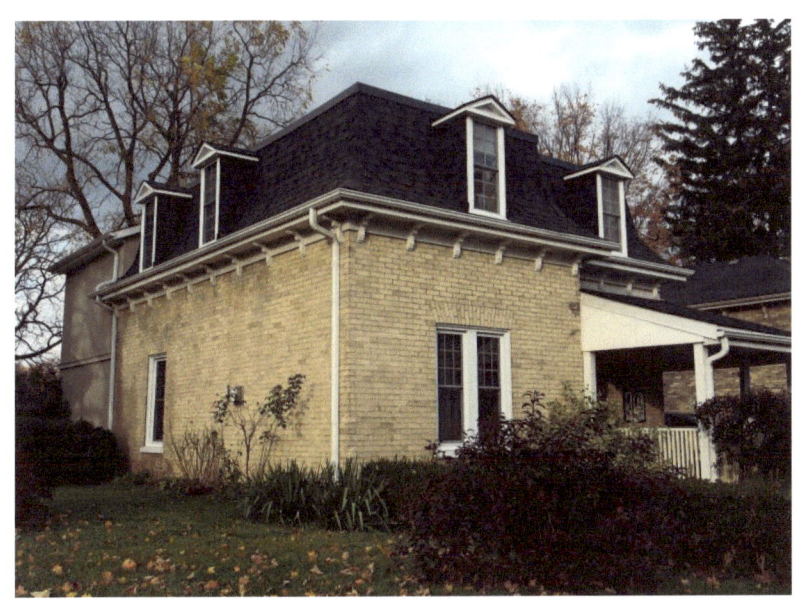

234 Main Street – Second Empire style – mansard roof with dormers, cornice brackets, yellow brick

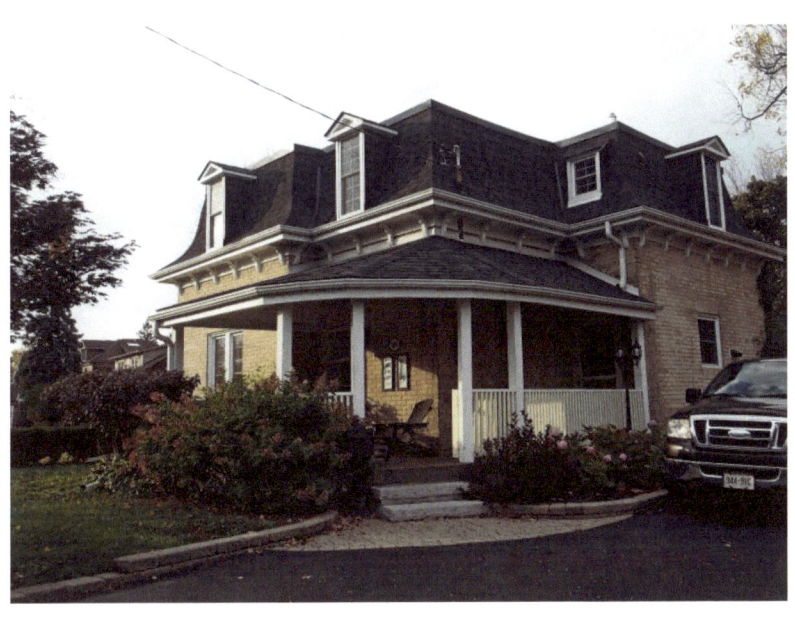

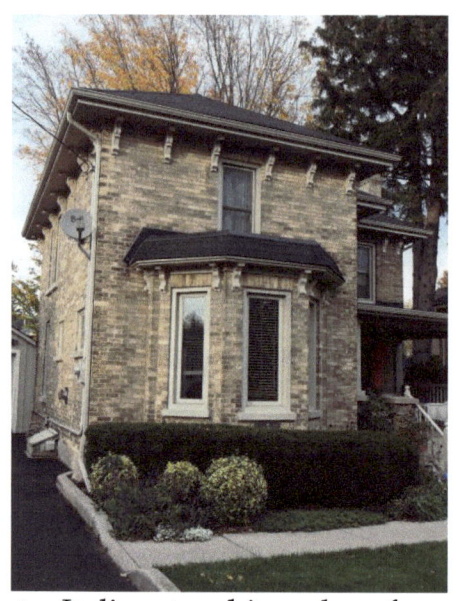

236 Main Street – Italianate – hipped roof, cornice brackets, bay window

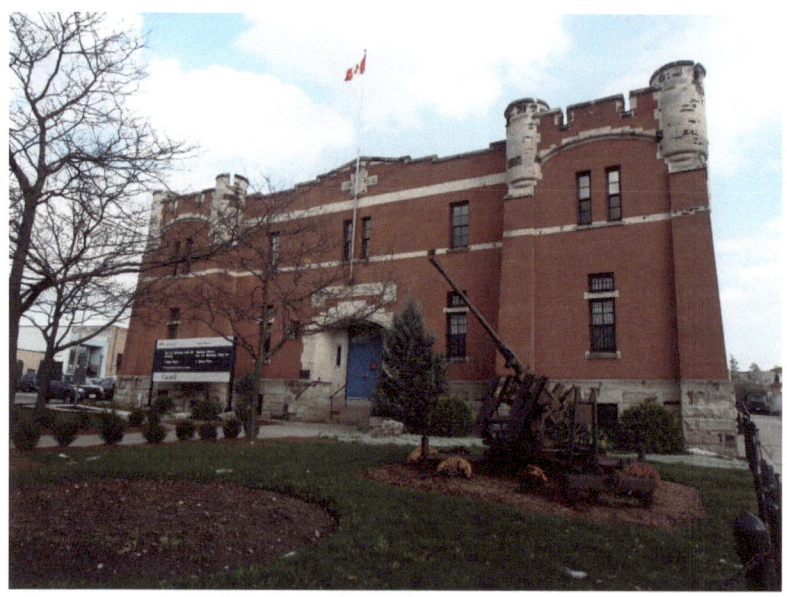

McIntosh Galt Armoury

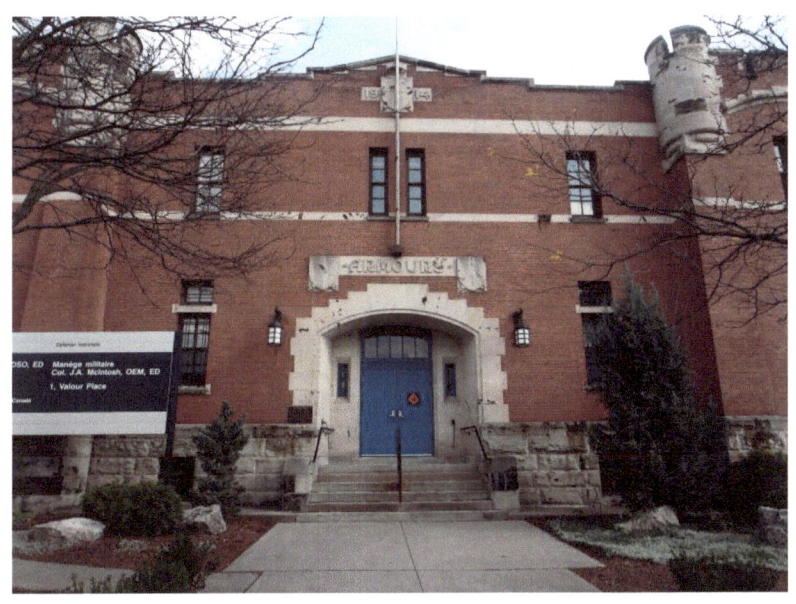

1 Valour Place – McIntosh Galt Armoury

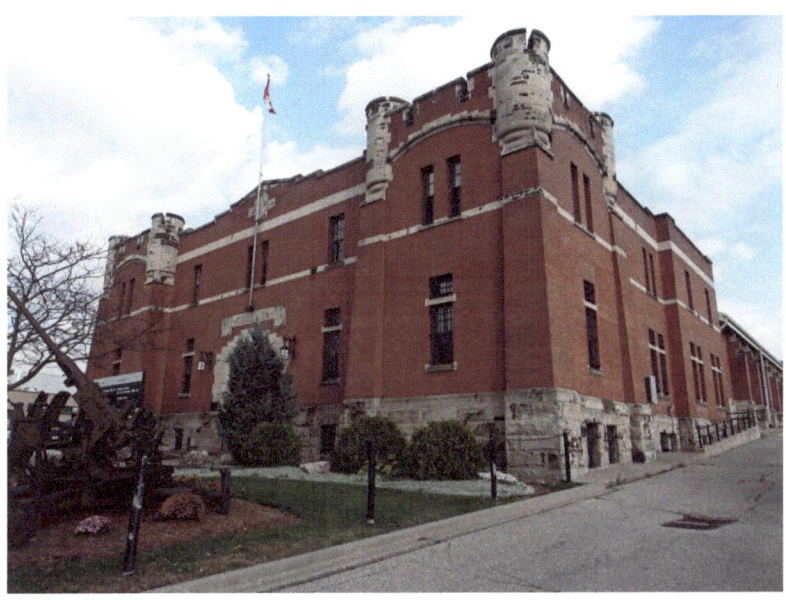

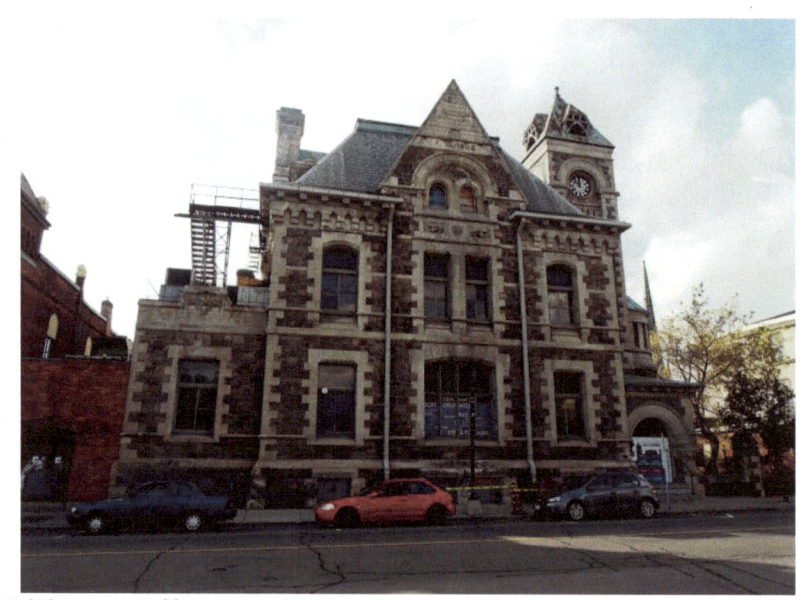
Old Post Office on Water Street – A.D. 1883 – clock tower

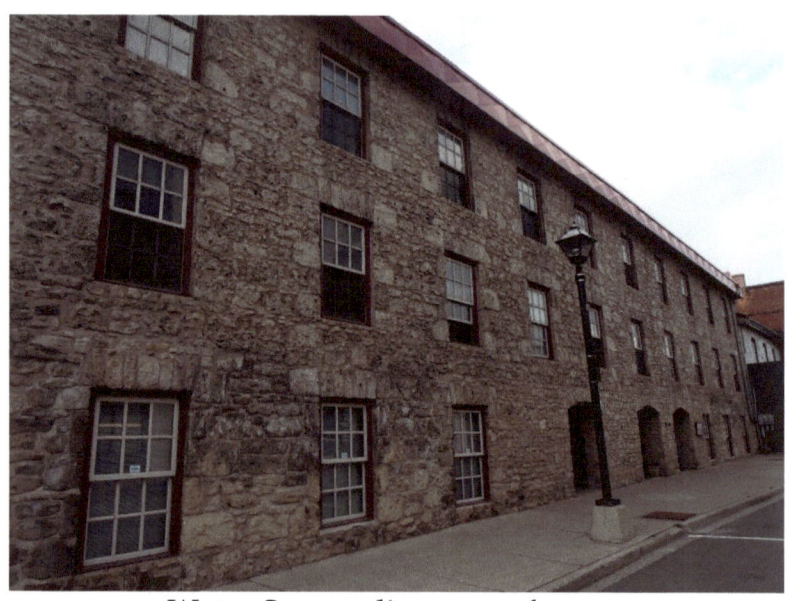
Water Street – limestone factory

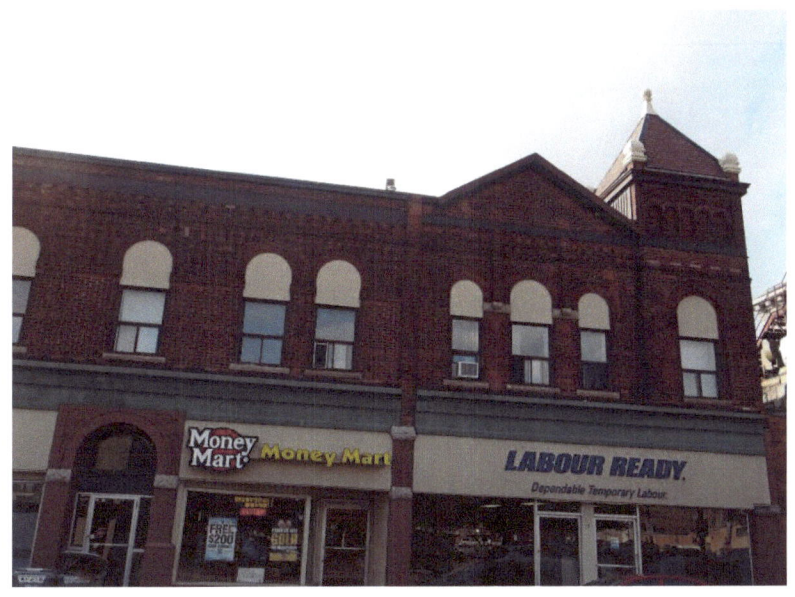

Water Street – arched window hoods, dentil moulding

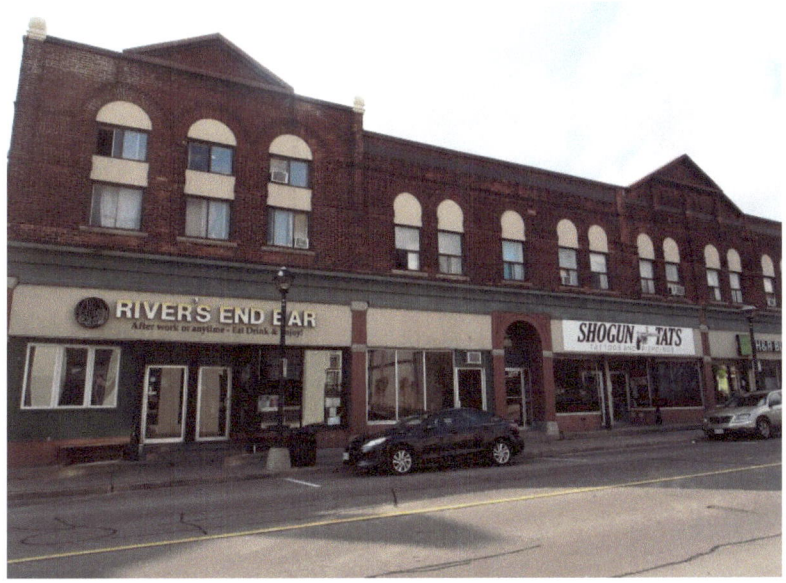

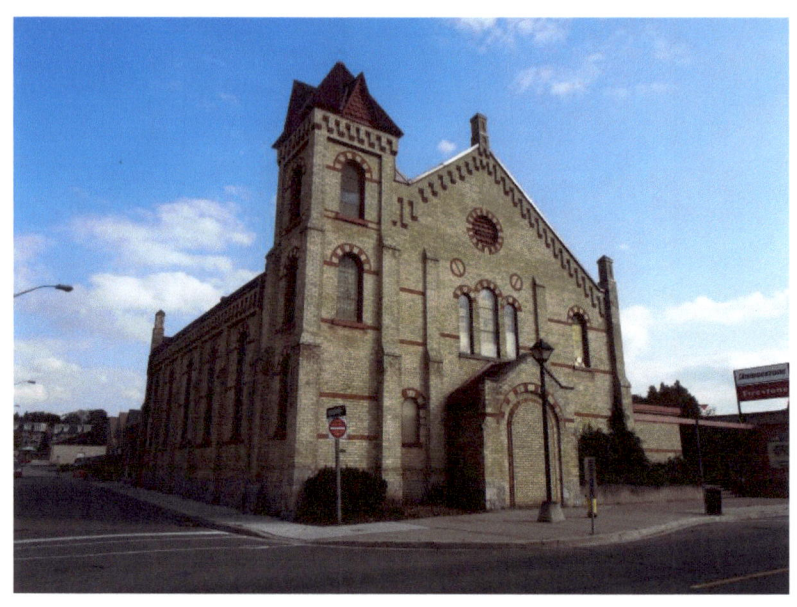

Former Church on Water Street – dichromatic brickwork, Gothic Revival style – now Cambridge Arts Theatre

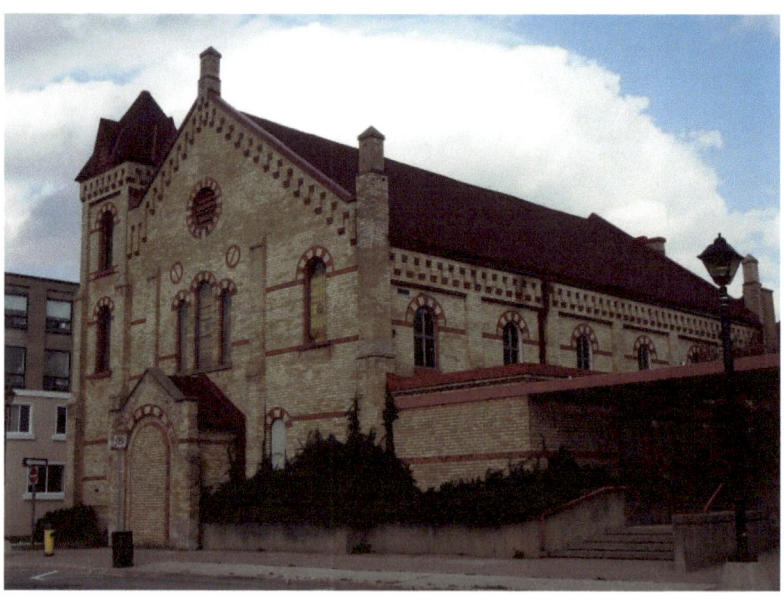

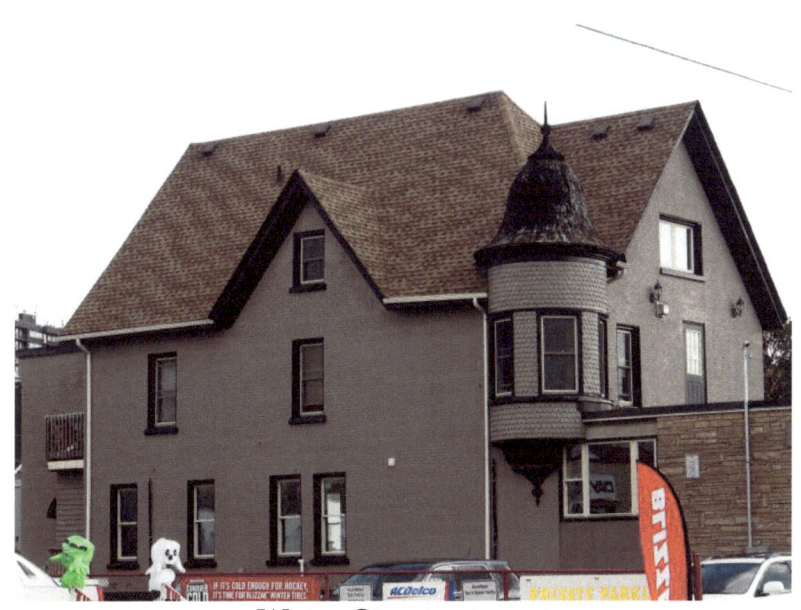

Water Street – turret

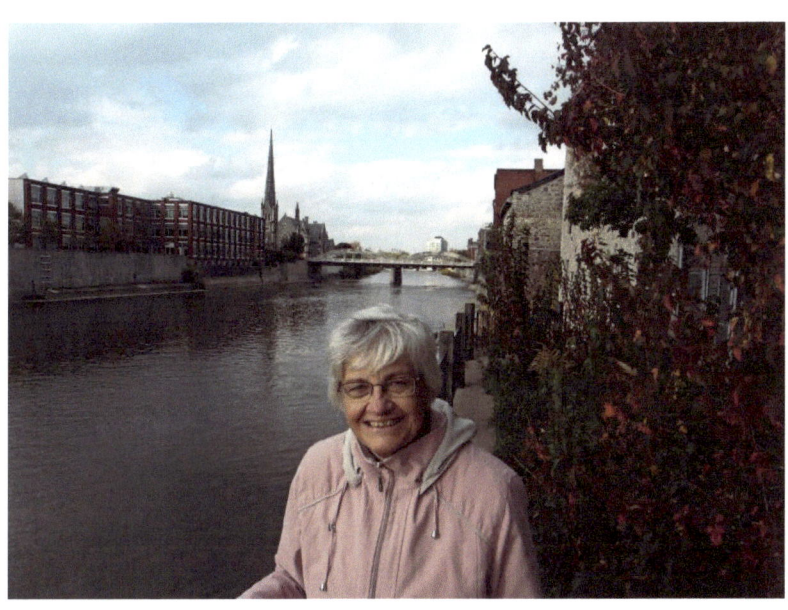

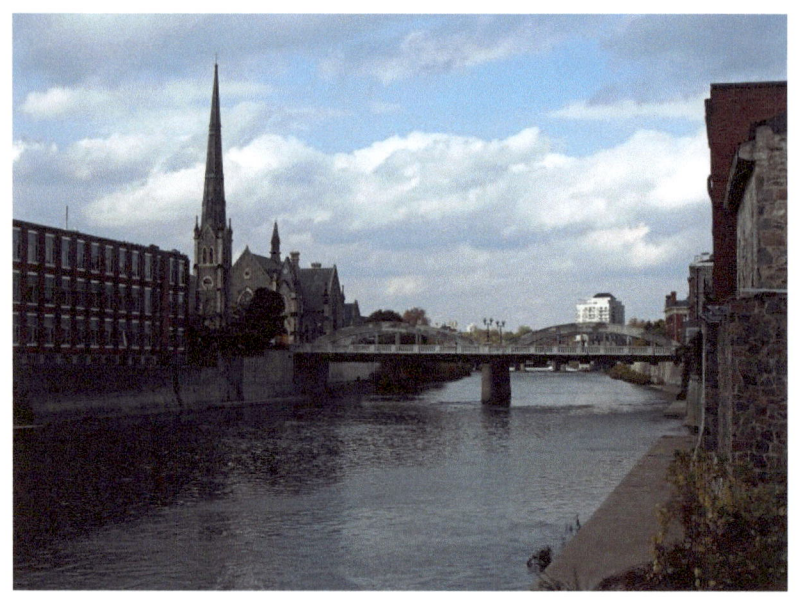

View along waterfront – Main Street arched bridge

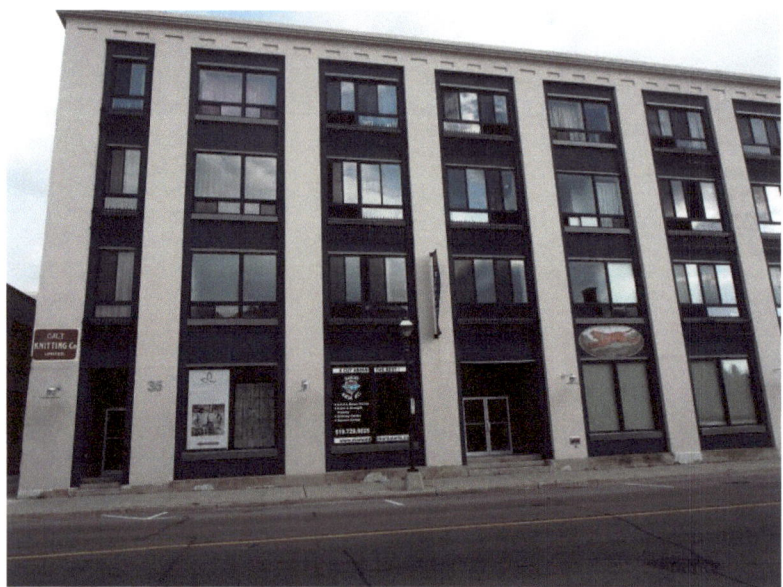

25 Water Street – former Galt Knitting Company Ltd.

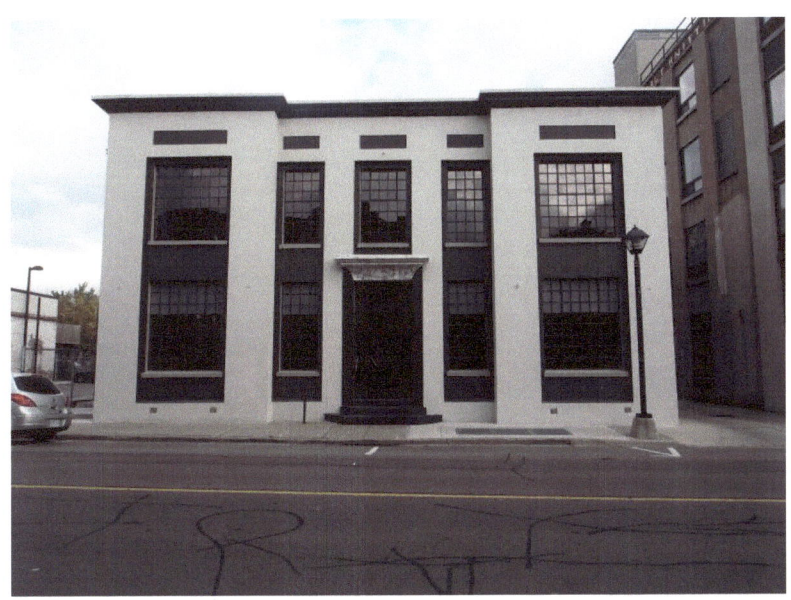

Water Street

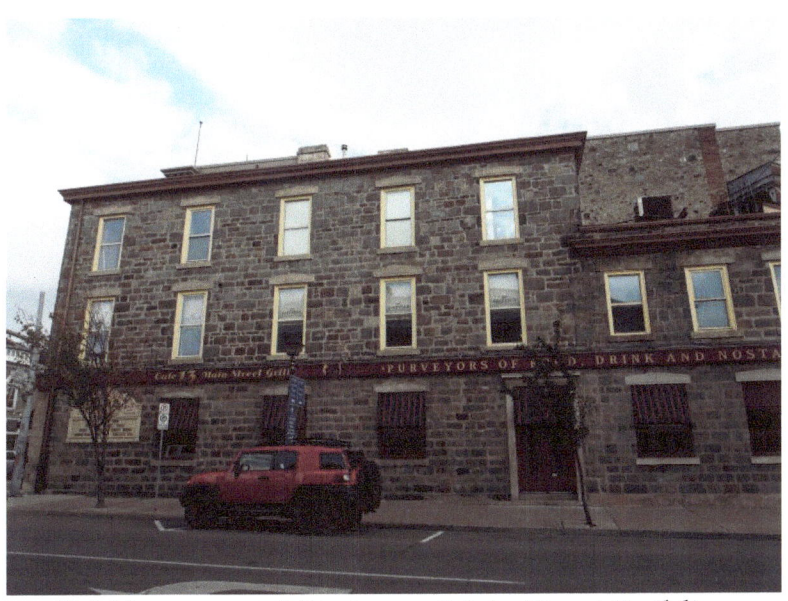

Cobblestone architecture – Main Street Building

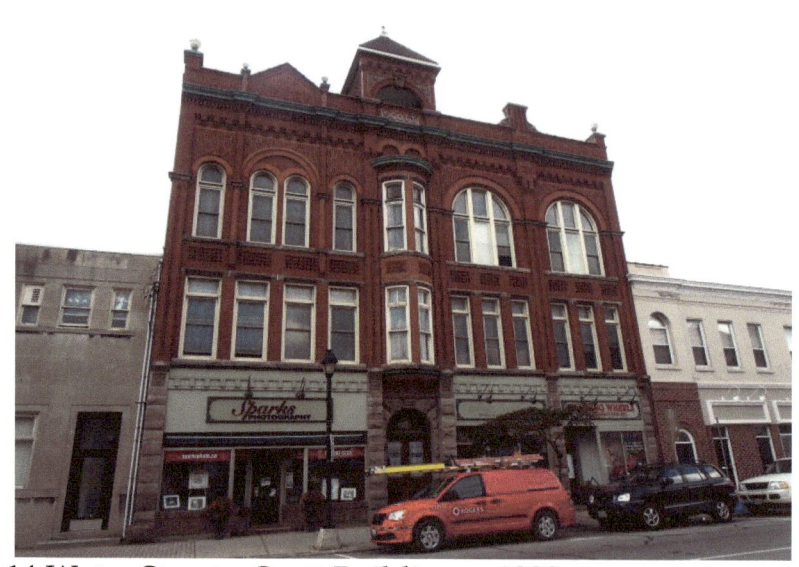

10-14 Water Street – Scott Building c. 1890 - two-storey tower-life bay above doorway topped with a cupola, dentil moulding, decorative brickwork, arched window hoods

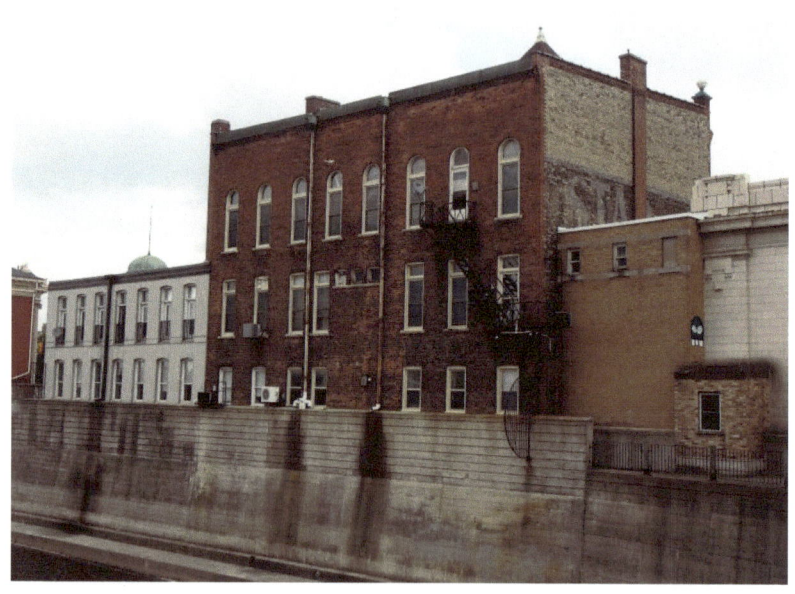

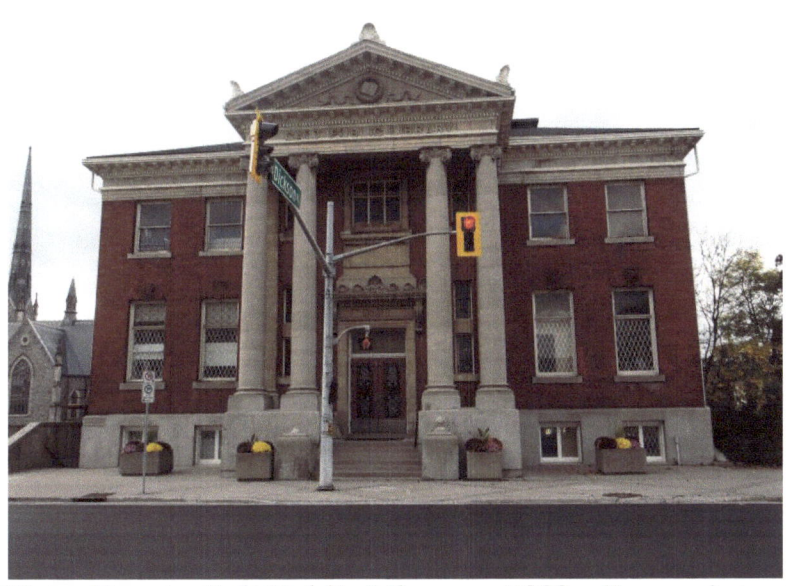

34 Water Street - Galt Public Library – 1903 – Beaux Arts style with pillars topped with capitals, triangular pediment with three acroterions, and the tympanum decorated with a Renaissance wreath surrounding an open library book; dentil moulding. The cornice over the door has a central acroterion as well as two acroterions on the corners.

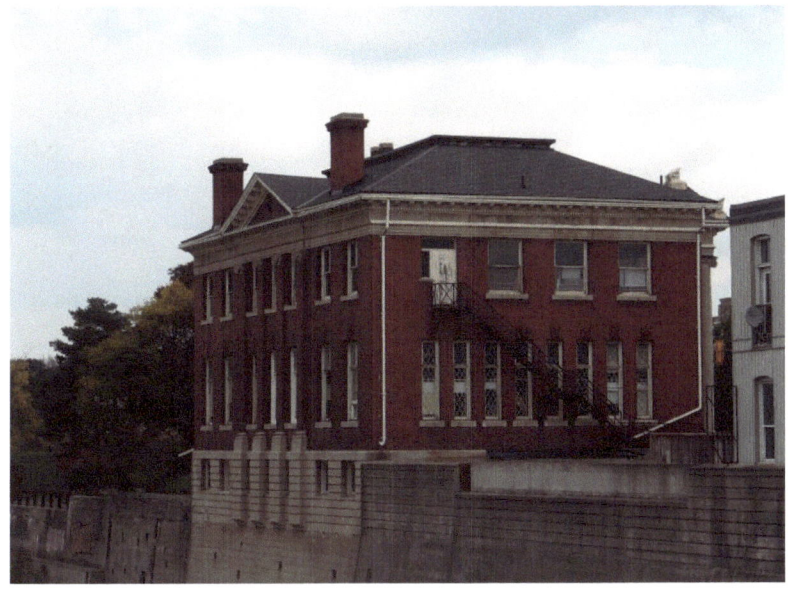

Water Street – arched window hoods and keystones, buttresses topped with scrolled capitals

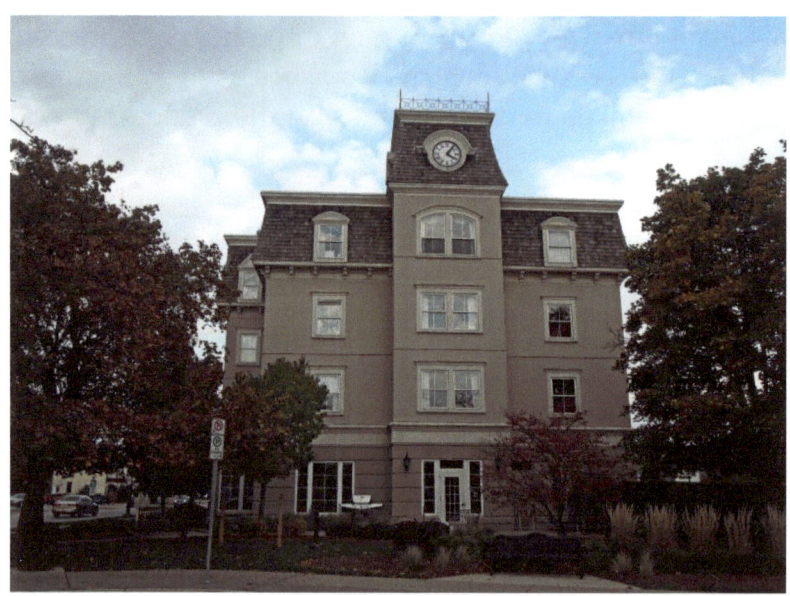

Queen's Square Terrace Retirement Residence – Second Empire – mansard roof, clock tower, iron cresting on rooftop

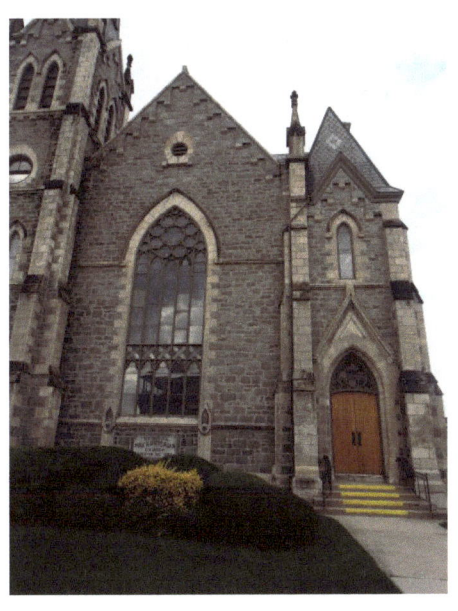

7 Queen's Square, Central Presbyterian Church erected A.D. 1880 – cobblestone architecture, dichromatic tile work on steeple and roof, lancet windows, buttresses

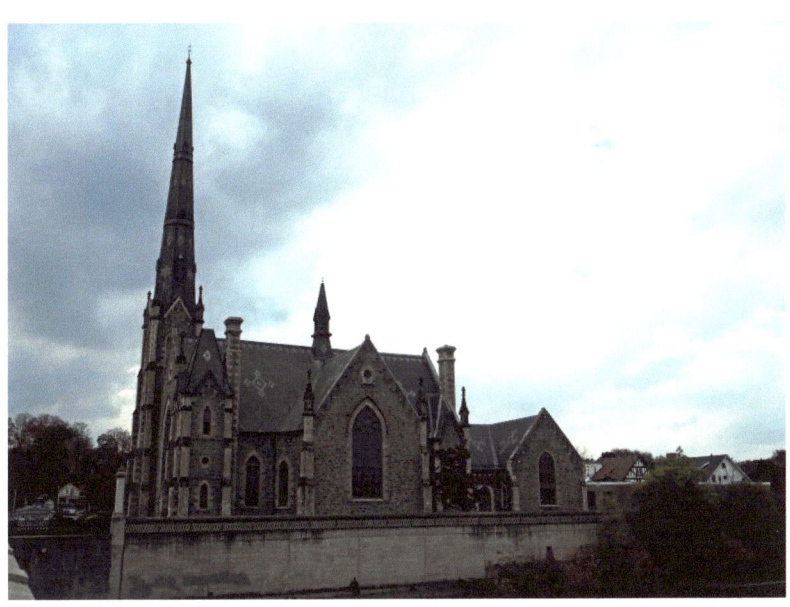

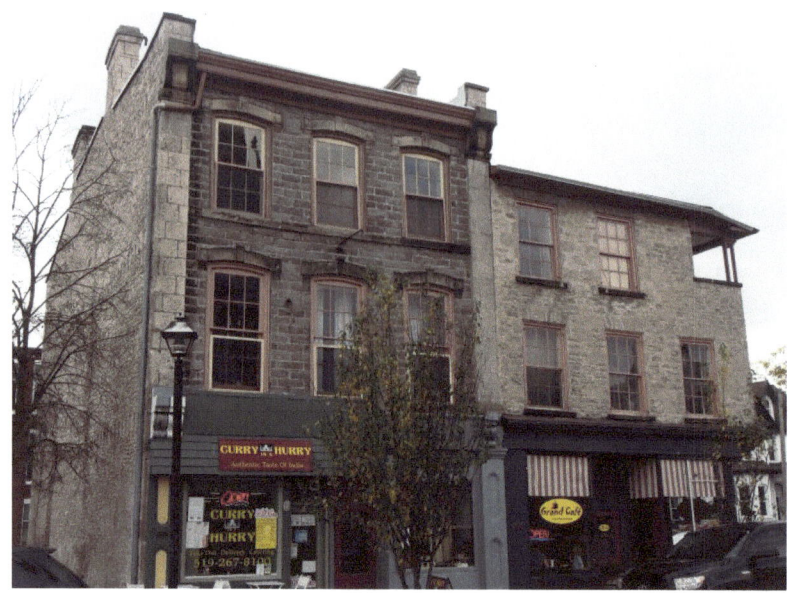

South Square

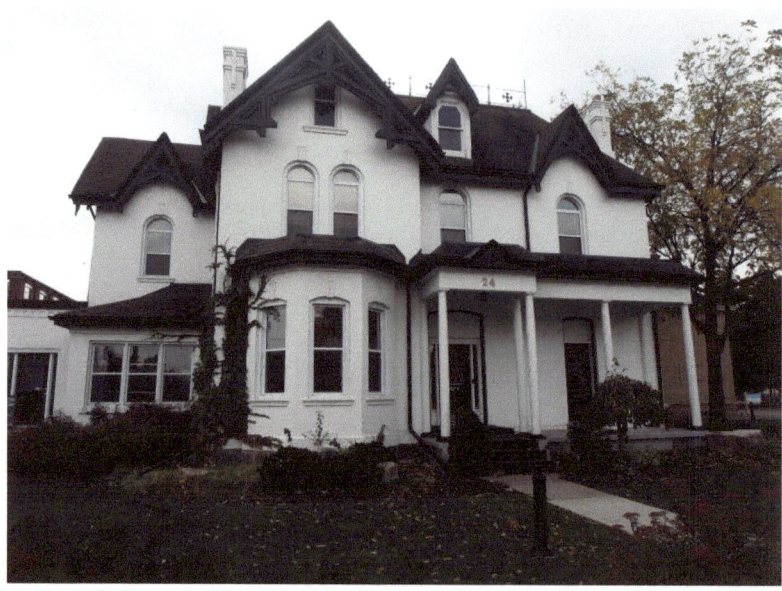

24 South Square – Gothic Revival, Vergeboard trim, iron cresting on the rooftop

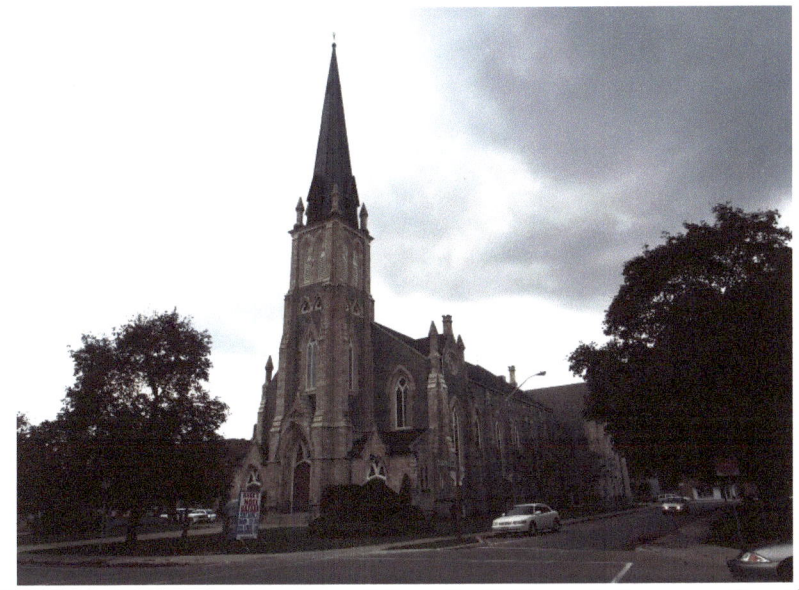

Knox's Galt Presbyterian Church, 2 Grand Avenue South

40 Grand Avenue South - Italianate

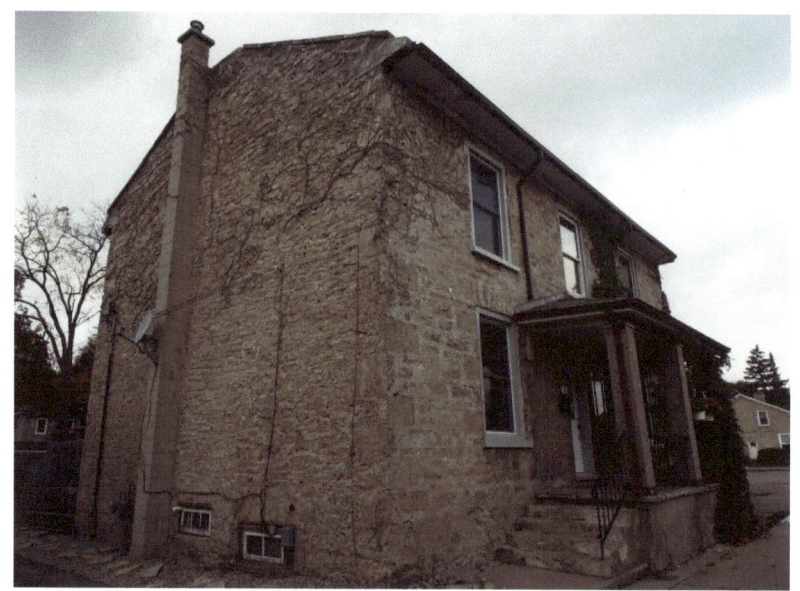
42 Grand Avenue South – limestone

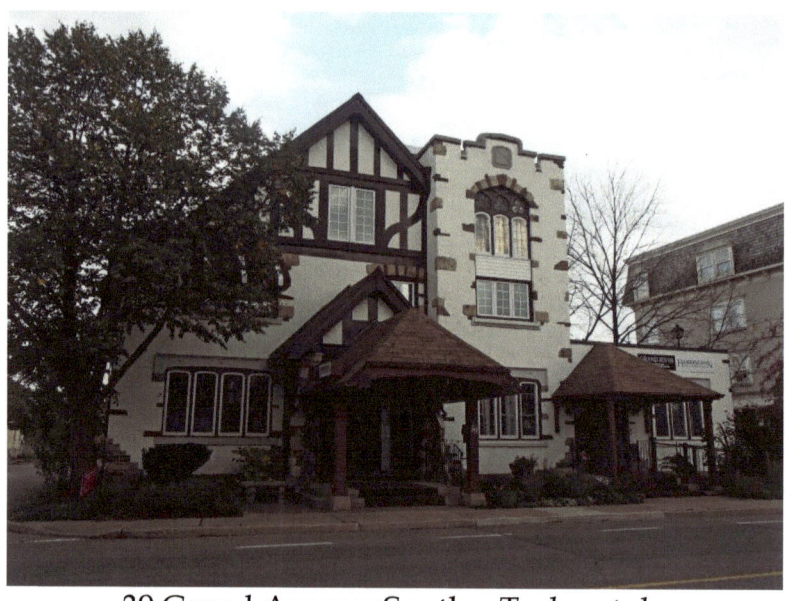
39 Grand Avenue South – Tudor style

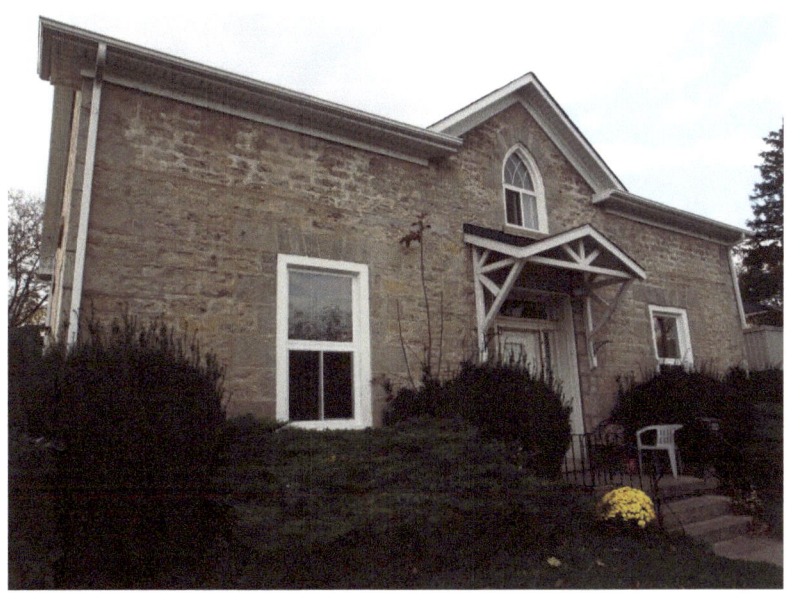

54 Grand Avenue North – limestone – Gothic cottage

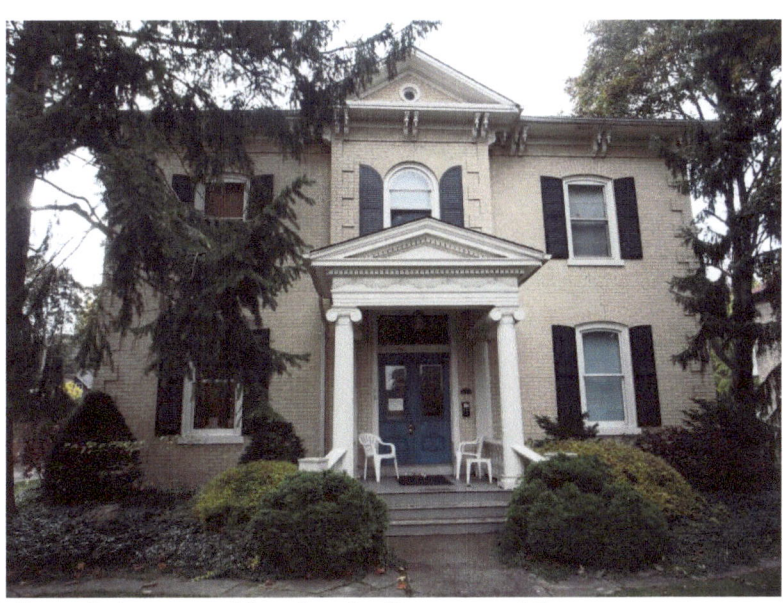

58 Grand Avenue North – Italianate with two-storey tower-like bay with triangular pediment at roof and another pediment above doorway, cornice brackets, quoins on edges of tower and on house corners

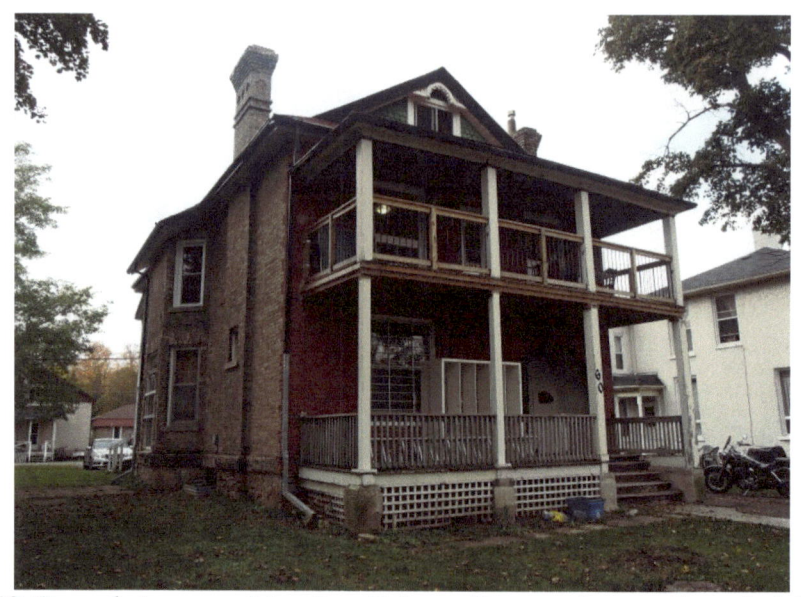

60 Grand Avenue North – Edwardian style – yellow brick

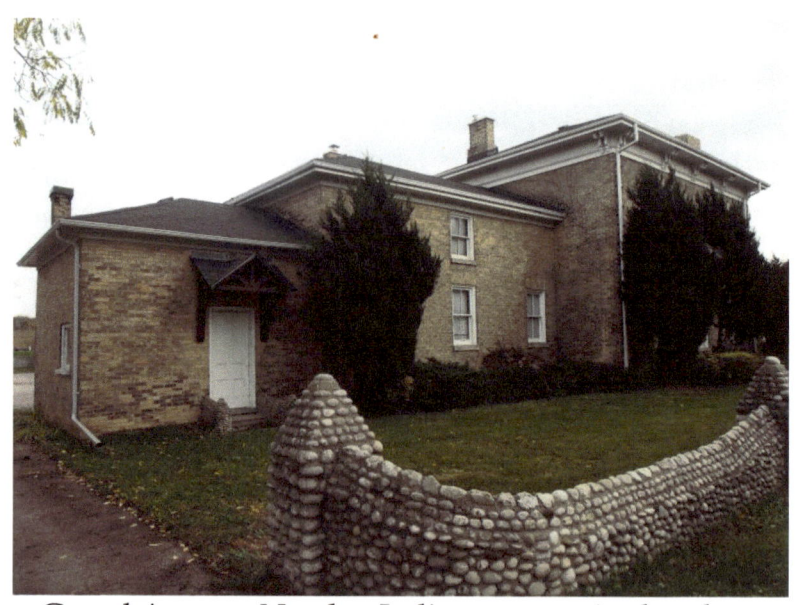

Grand Avenue North – Italianate, cornice brackets – yellow brick

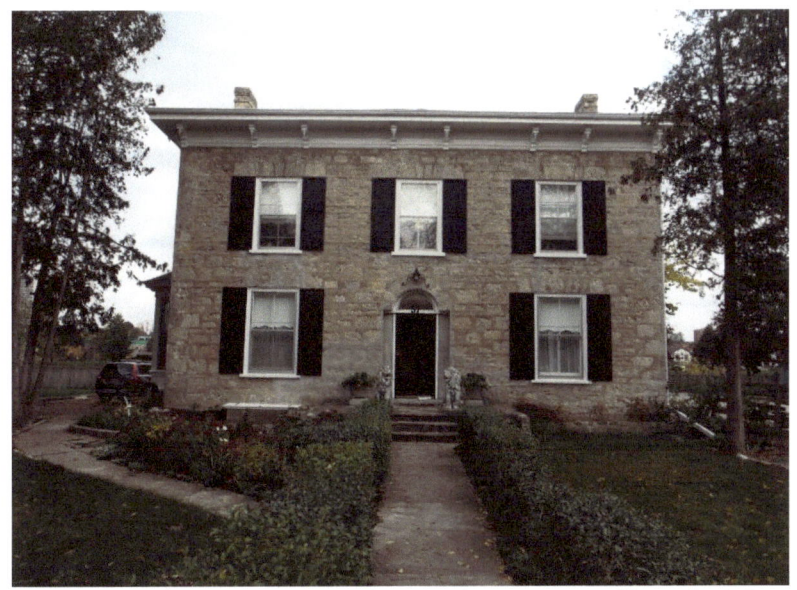

57 Grand Avenue North – Italianate – yellow brick

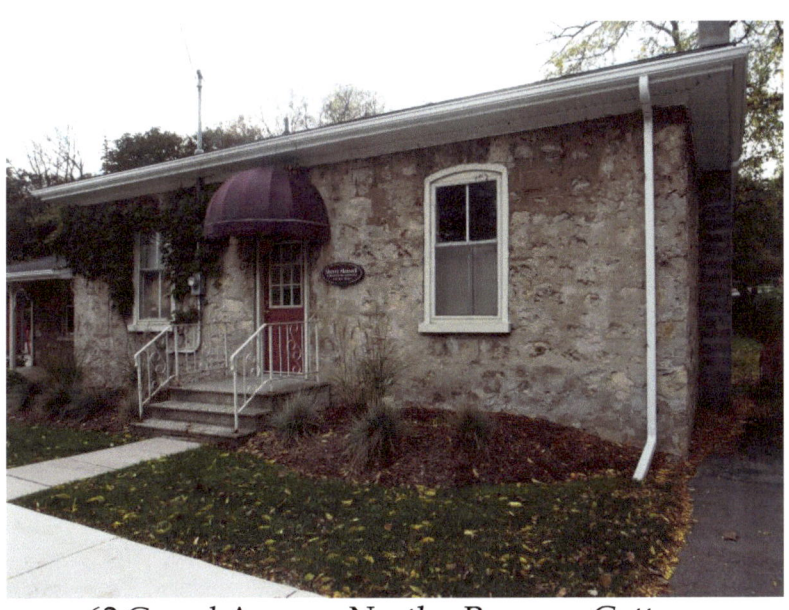

62 Grand Avenue North - Regency Cottage

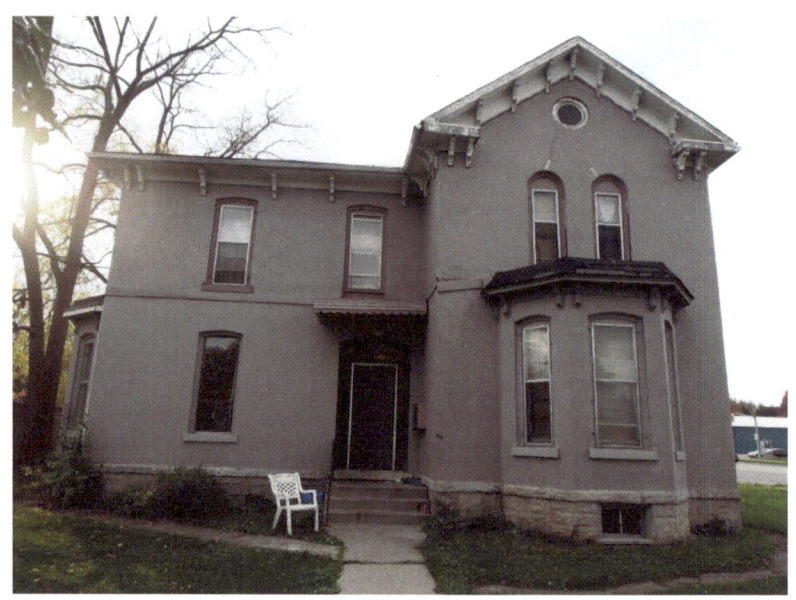

74 Grand Avenue North – Italianate/Gothic – cornice return on gable, cornice brackets

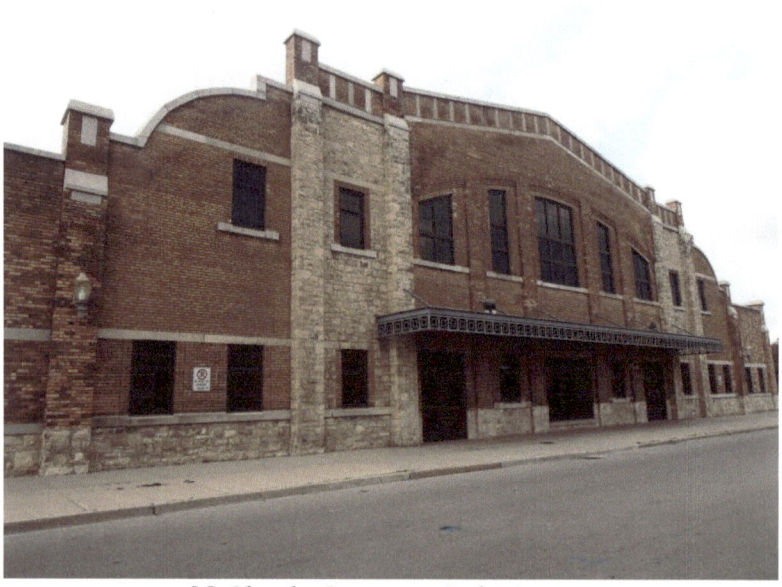

98 Shade Street – Galt Arena

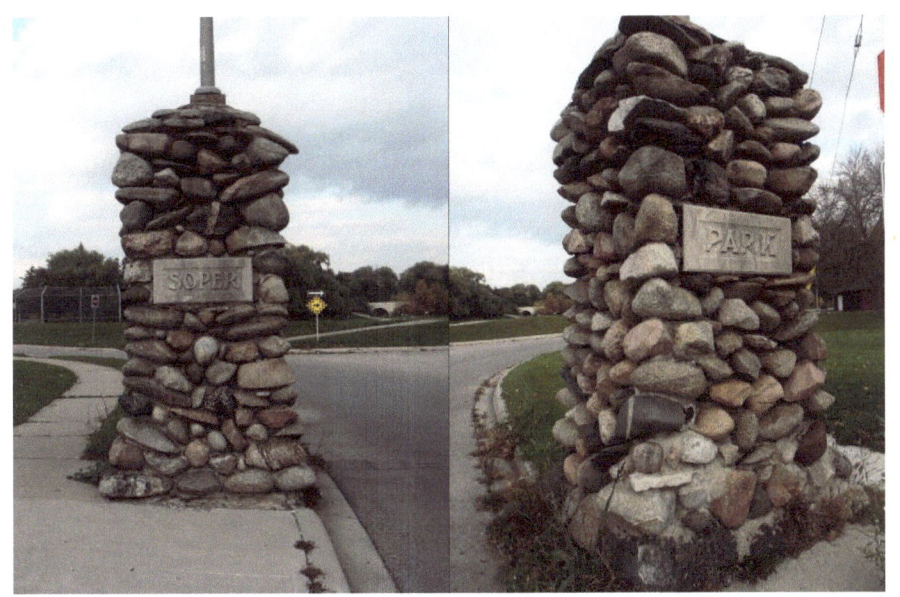

Soper Park – 1920 – Shade Street

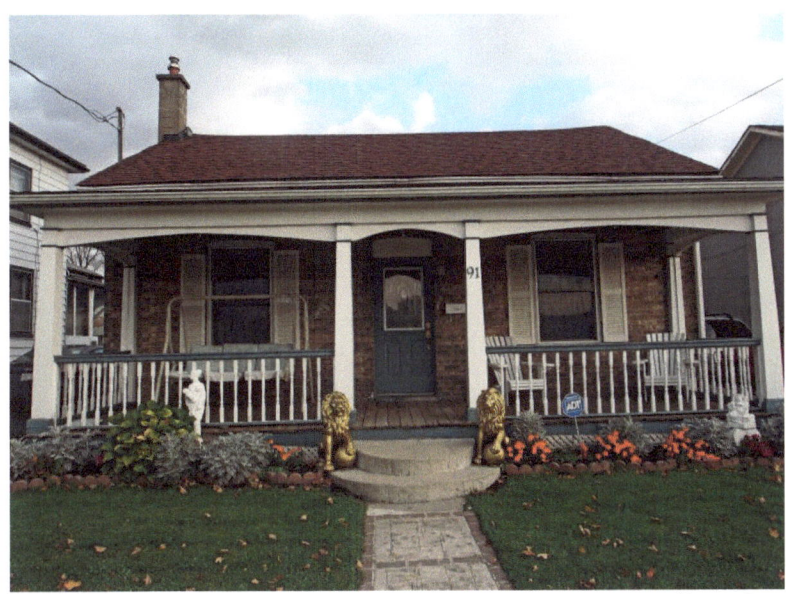

91 Shade Street – one floor Regency Cottage – yellow brick

Shade Street – yellow brick – Regency Cottage, corner quoins

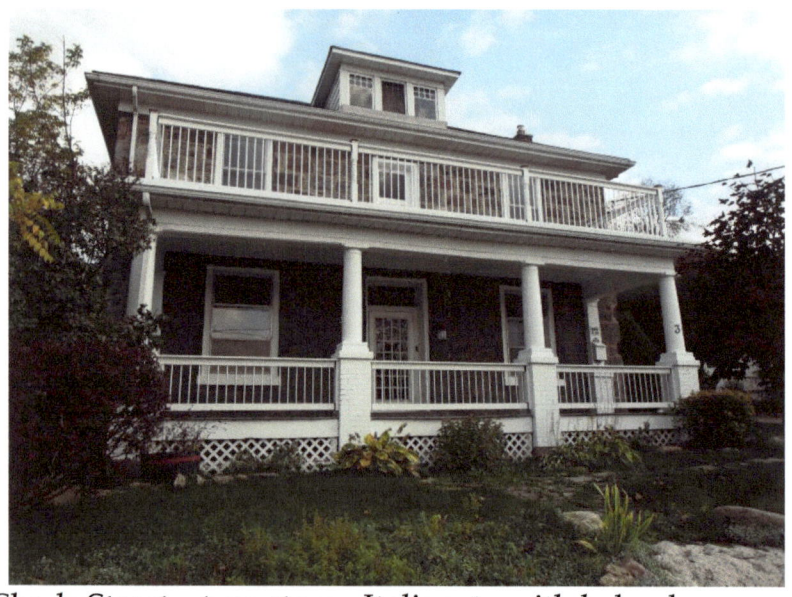

31 Shade Street – two-storey Italianate with belvedere on roof, second floor full-width balcony, first floor full-width verandah

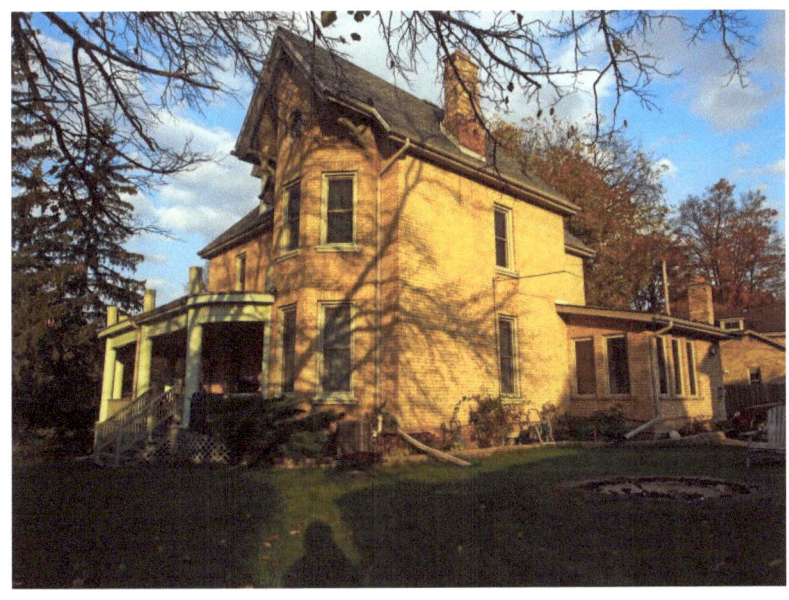

Spruce Street – Italianate with 2½ storey tower-like bay with fretwork resembling brackets, dormer in attic

17 and 19 Shade Street – cobblestone architecture

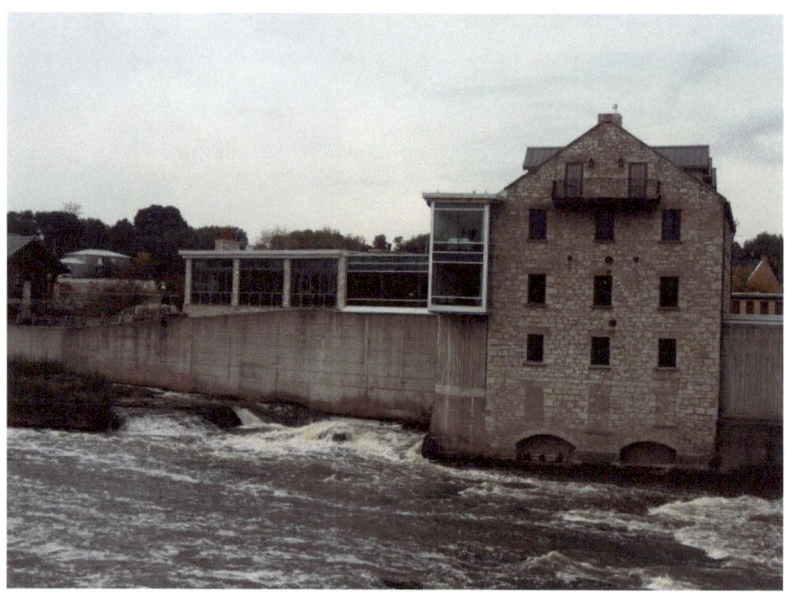

Limestone building on the Grand River – old mill

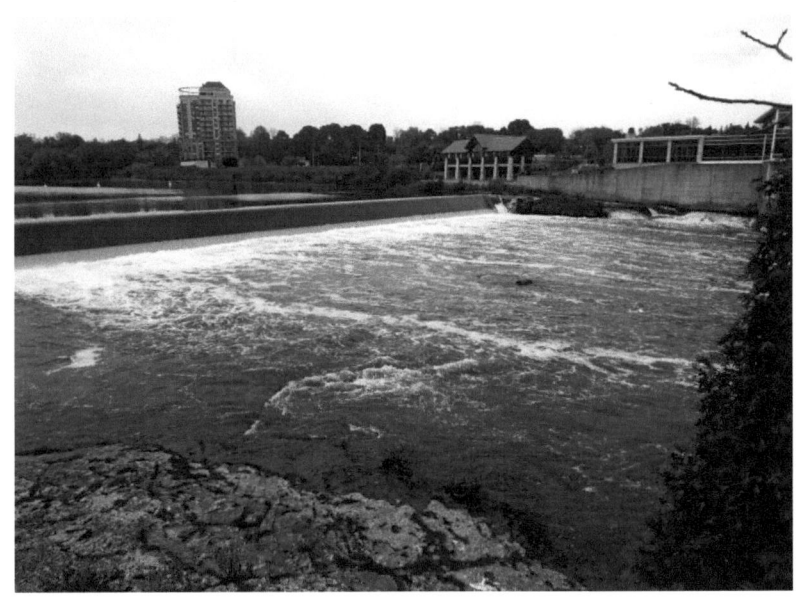

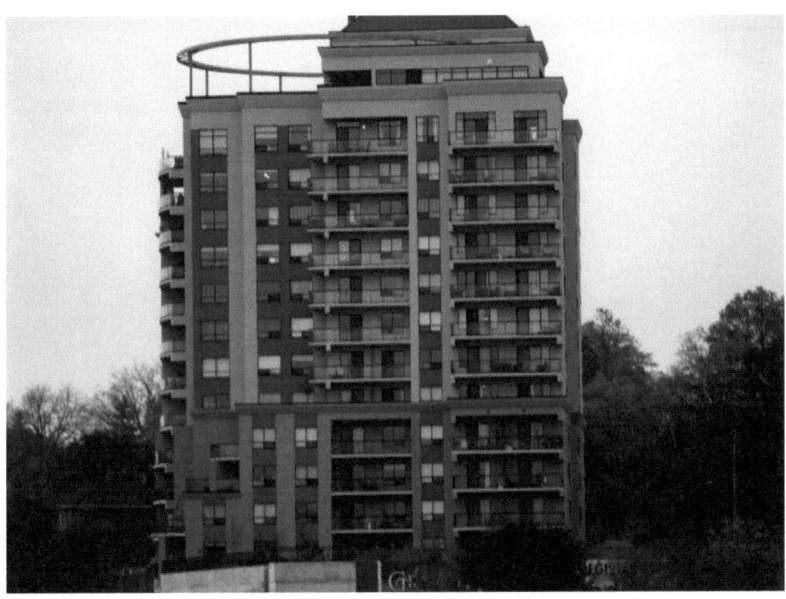
Modern apartment building

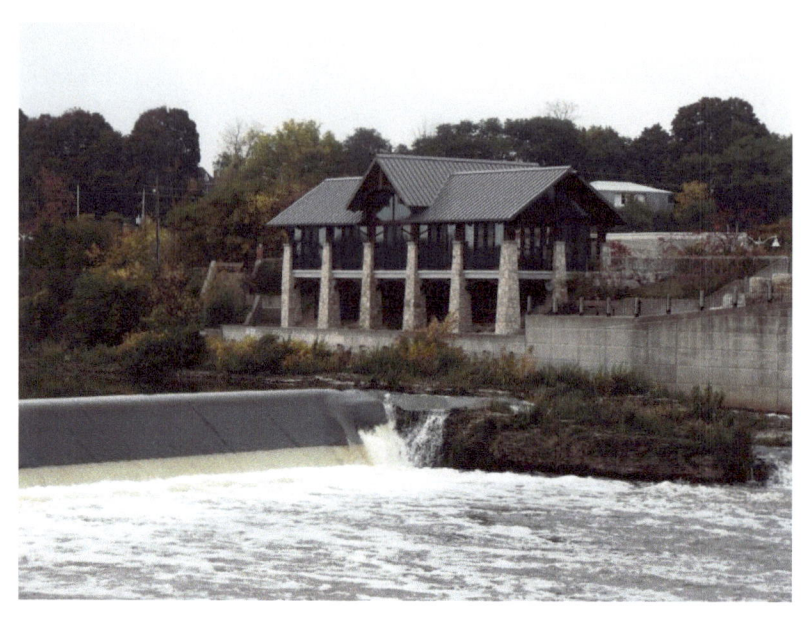

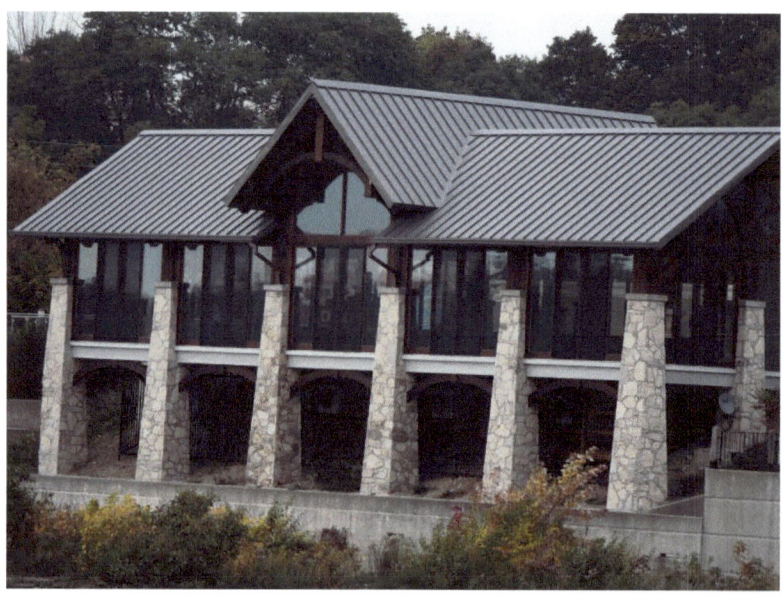

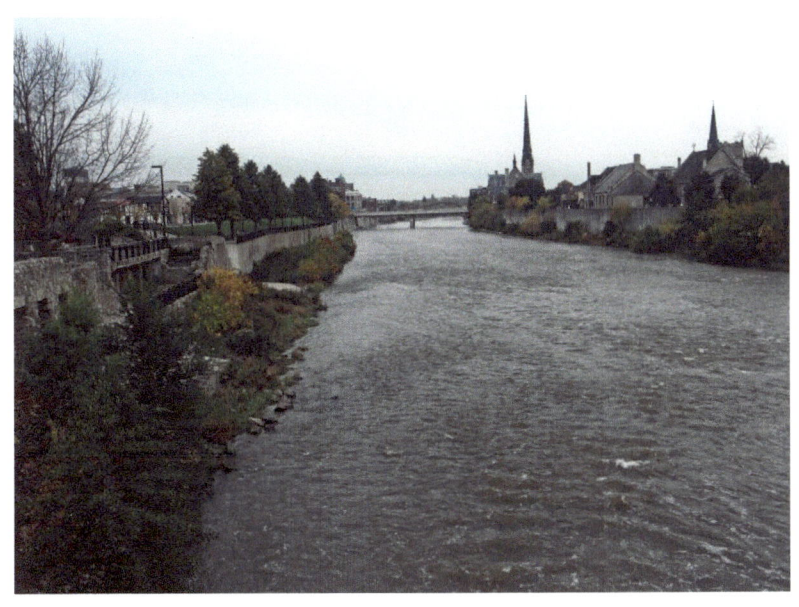

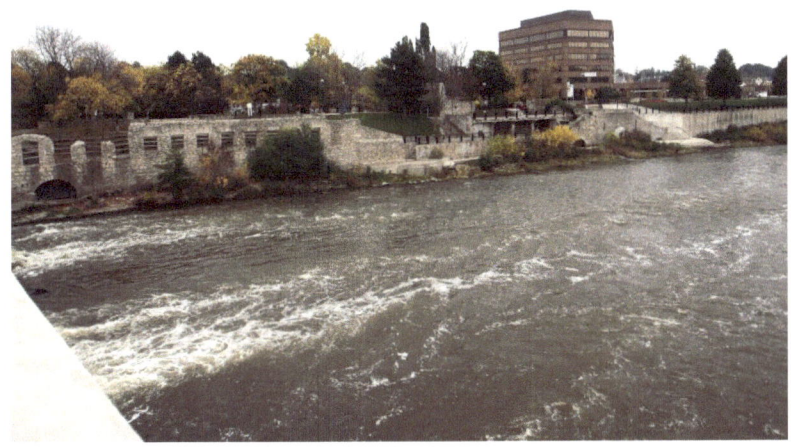

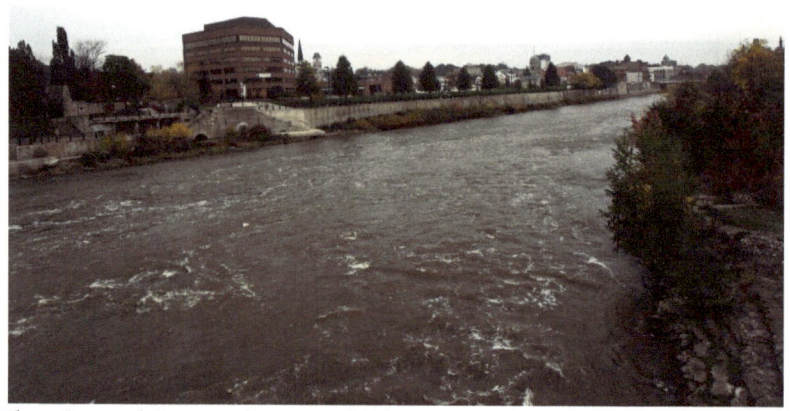

The Grand River flows 290 kilometres from the Dundalk Highlands to Lake Erie. Winding its way through marshes, woods and Carolinian forests, the river provides the common thread that links a harmonious blend of natural and cultural landscapes.

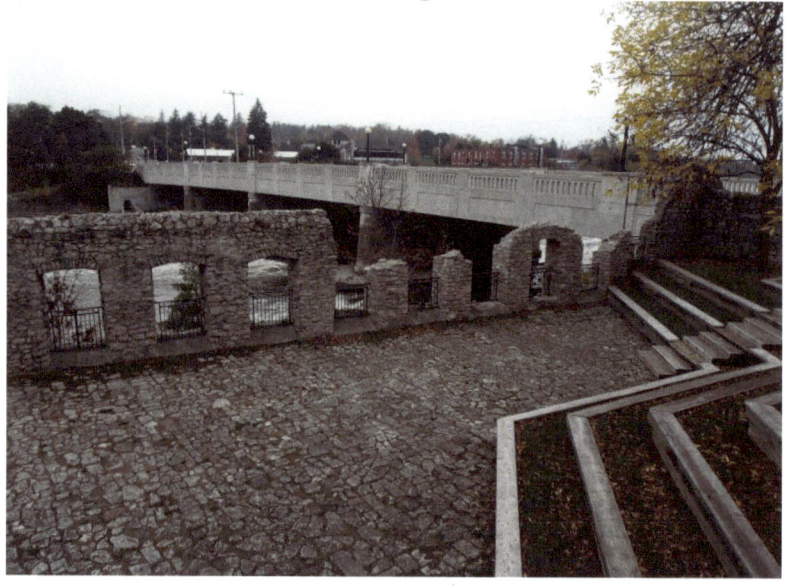

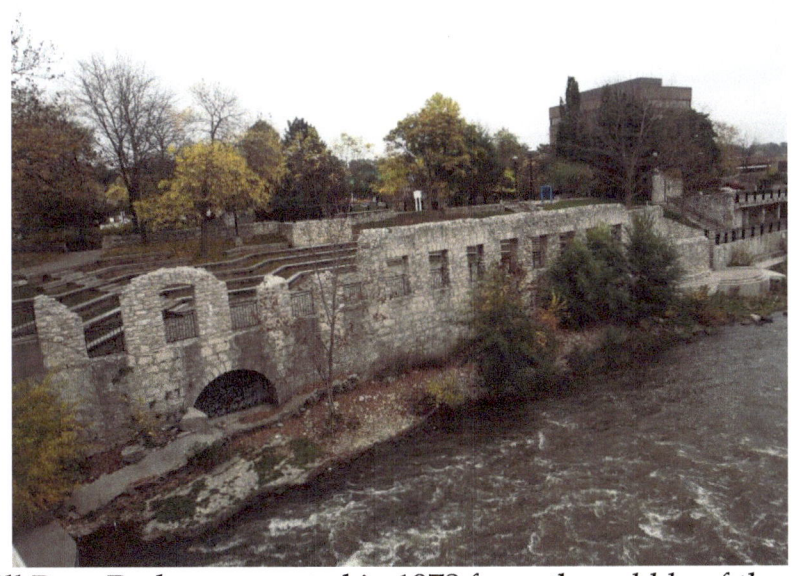

Mill Race Park was created in 1978 from the rubble of the old Turnbull Woollens Mill – riverside amphitheatre

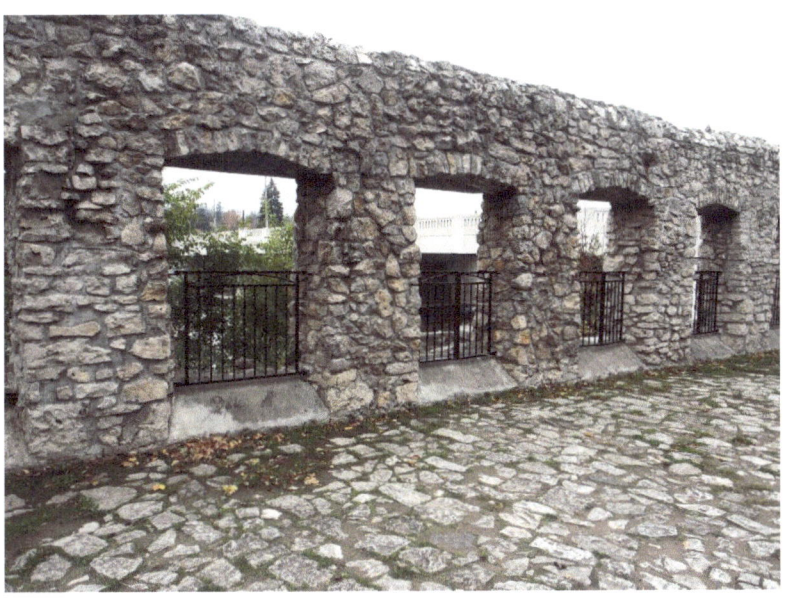

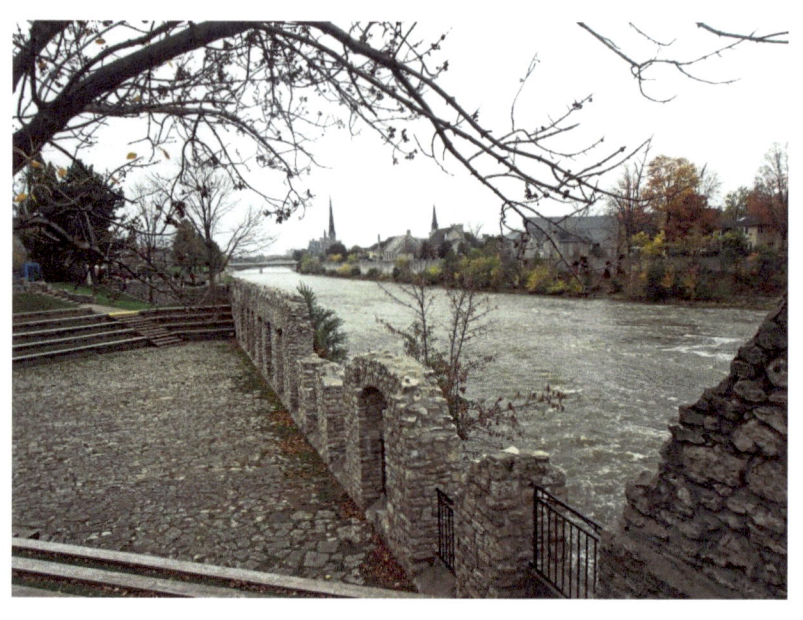

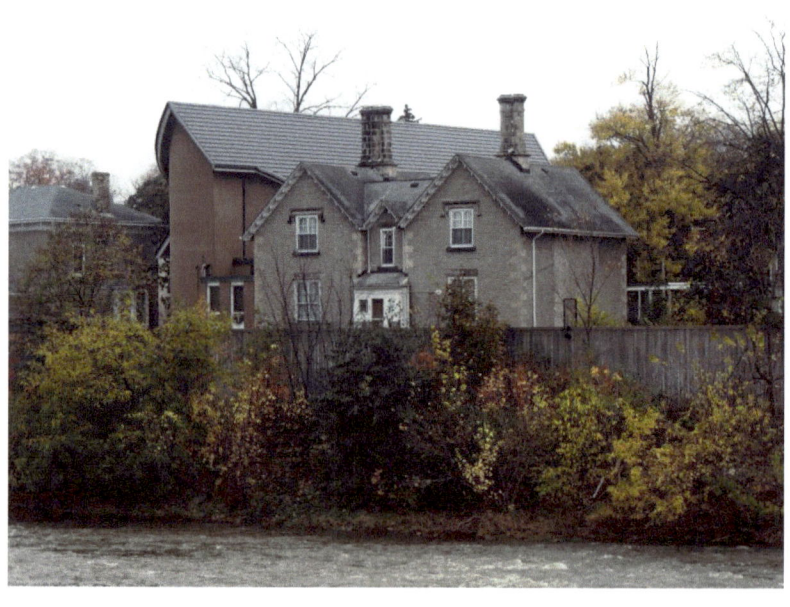

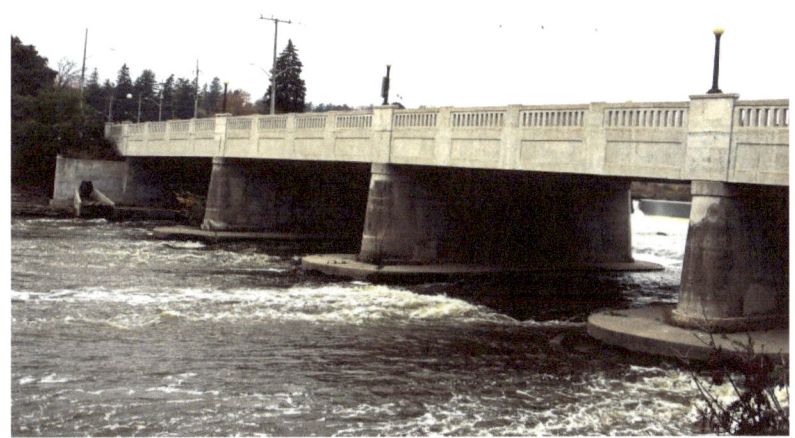

Park Hill Road Bridge (formerly Queen Street) – built in 1934

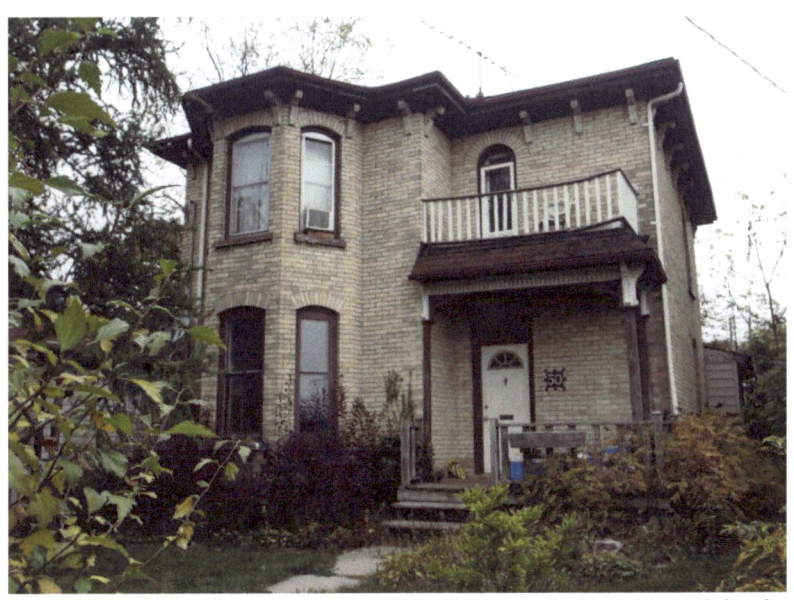

50 Frazer Street – Italianate with two-storey tower-like bay, cornice brackets, yellow brick

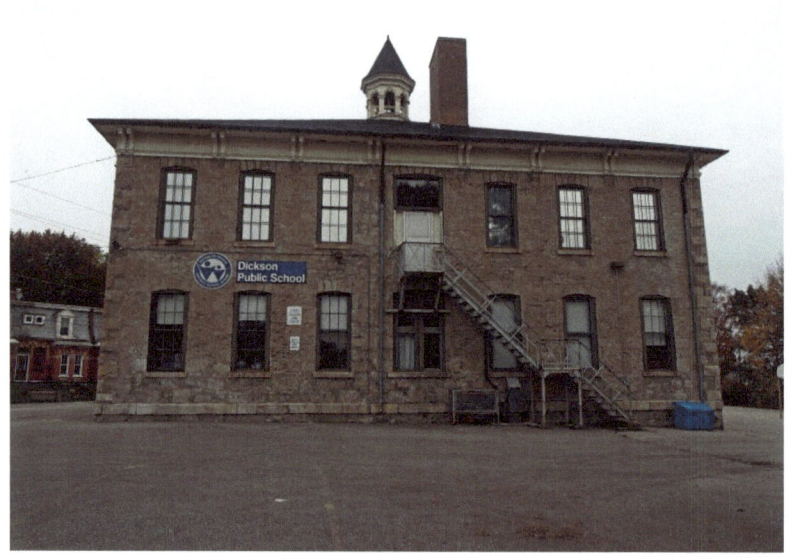

65 St. Andrews Street – Dickson Public School

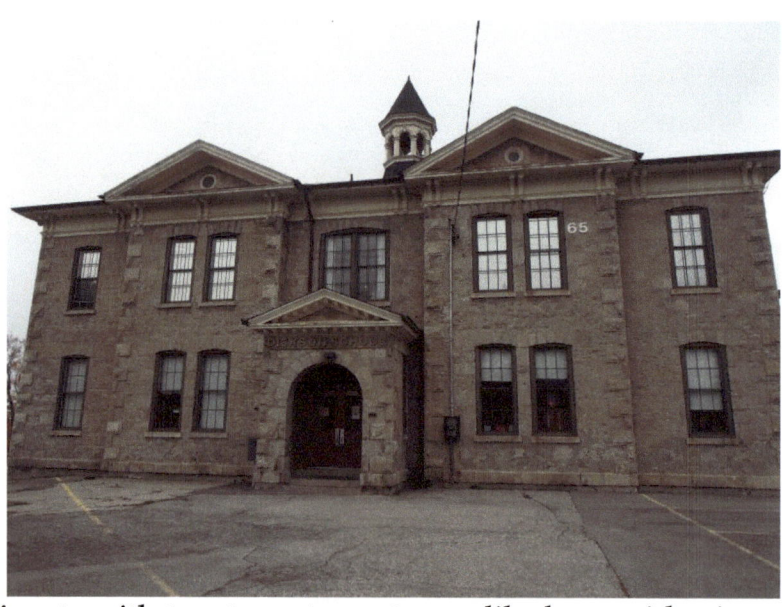

Italianate with two two-storey tower-like bays with triangular pediments, cupola on rooftop, cornice brackets, corner quoins

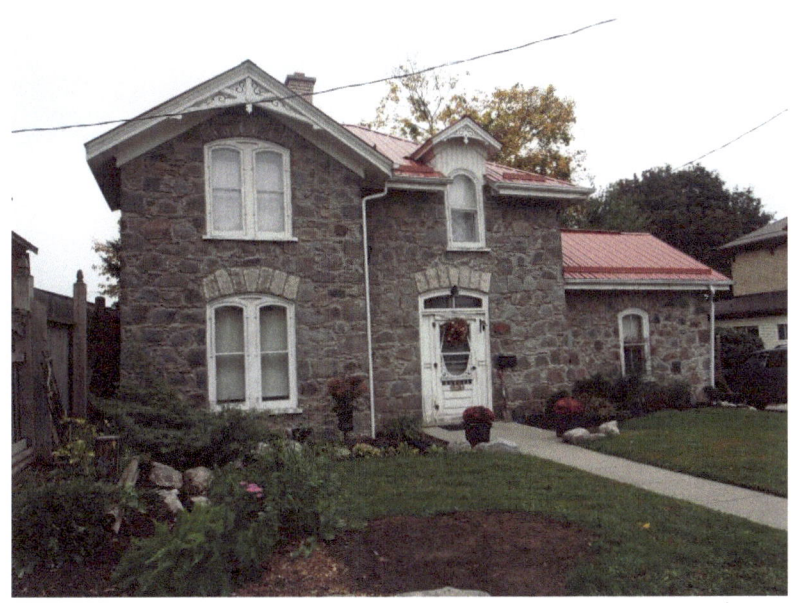

7 Cant Avenue – cobblestone – Gothic Revival

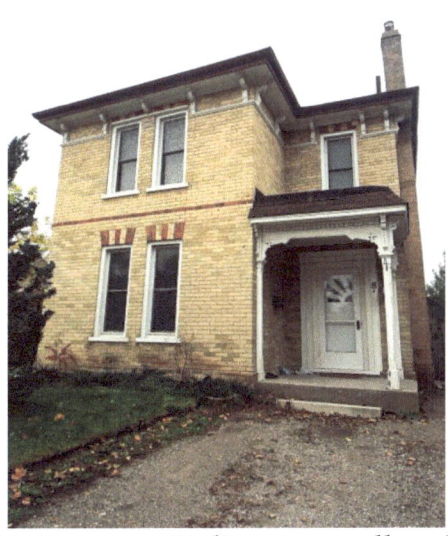

8 Cant Avenue – Italianate – yellow brick, dichromatic brickwork, cornice brackets

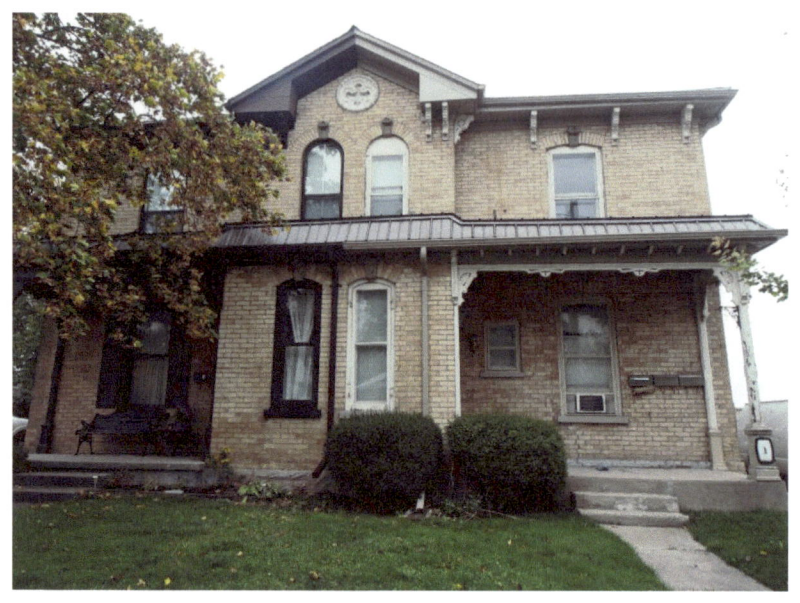

1 and 3 Cant Avenue – Italianate, single cornice brackets, two-storey tower-like bay centre front, and on end of building

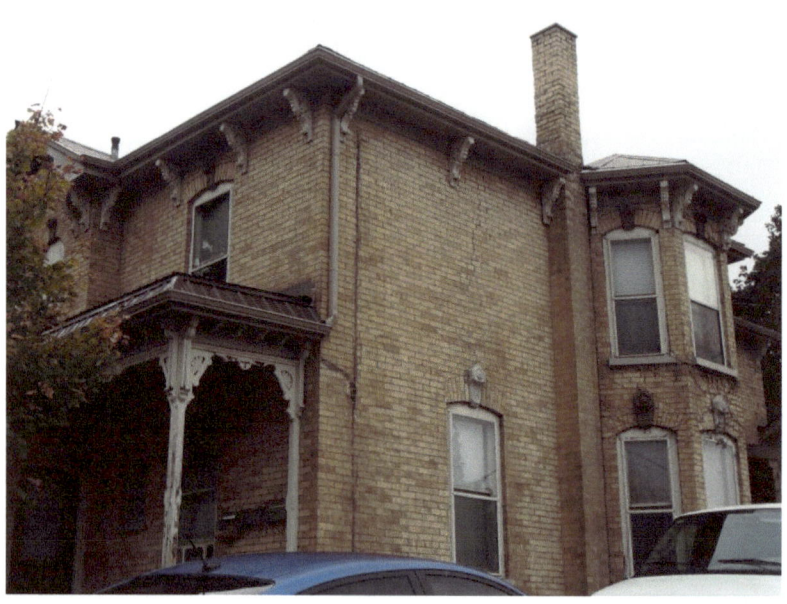

The Galt Grammar School was established in 1852 and William Tassie became headmaster the following year. Under his direction the Galt School, familiarly known as "Tassie's", attained widespread recognition and attracted students from all over the continent. The oldest part of the stone building is from 1853.

Architectural Terms

Acroterion: an architectural ornament placed on a flat base Example: Galt Public Library, Water Street	
Belvedere: (from the Italian "beautiful view") an architectural feature on a roof, in a garden or on a terrace that gives a beautiful view. Example: 31 Shade Street	
Brackets: a decorative or weight-bearing structural element which forms a right angle with one side against a wall and the other under a projecting surface such as an eave or roof.	
Buttress: a masonry structure built against or projecting from a wall which serves to support or reinforce the wall. In Canadian architecture, they are sometimes used for decoration. Example: Water Street	
Cobblestone architecture: Refers to the use of cobblestones embedded in mortar as a method for erecting walls on houses and commercial buildings. Example: Main Street	
Cornice: originally the wooden overhang of the roof. With the use of stone, brick, iron and steel, the cornice is any projecting shelf at the top of a ceiling or roof. They can be very decorative. Example: 216 Main Street	
Cornice Return: decorative element on the end of a gable. Example: 74 Grand Avenue North	

Capital: The uppermost finish or decoration on a column. Example: Galt Public Library, Water Street	
Cupola: a small, dome-like structure on top of a building often used to provide a lookout or to admit light and air. Example: 65 St. Andrews Street, Dickson Public School	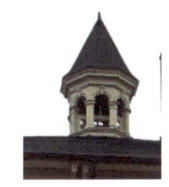
Dentil Moulding: an even series of rectangles used as ornamental decoration in cornices. Example: 10-14 Water Street	
Dichromatic brickwork: the use of two colours of brick, tile or slate to decorate a façade. Example: former church on Water Street	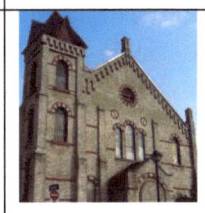
Dormer: (French for "sleep") a gable end window that pierces through the plane of a sloping roof surface to create usable space in the top floor or attic of a building by adding headroom. Example: Spruce Street	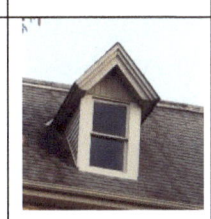
Entablature: the moldings and bands which lie horizontally above the columns, resting on their capitals. Example: Galt Public Library, Water Street	
Gable: the triangular portion of a wall between the edges of a sloping roof. Example: Spruce Street	

Keystones and Voussoirs: a voussoir is a wedge-shaped element used in building an arch. A keystone is the central stone that locks all the stones into position, allowing the arch to bear weight. A keystone is often enlarged and embellished. Example: Water Street	
Lancet Window: a tall, narrow window with a pointed arch at its top. Example: 7 Queen's Square, Central Presbyterian Church	
Mansard Roof: This style was popularized by Francois Mansart (1598-1666), an accomplished architect of the French Baroque period and especially fashionable during the Second French Empire (1852-1870). This roof is almost flat on the top section, with two slopes on each of its sides with the lower slope at a steeper angle than the upper and having dormer windows. Example: Queen's Square Terrace Retirement Residence	
Pediment: a triangular section above the horizontal structure (entablature), typically supported by columns. The inside of the triangle is called the tympanum. Example: Galt Public Library, Water Street	
Quoin: masonry blocks at the corner of a wall, often a decorative feature, usually larger or of a different colour than the rest of the wall. Example:	

Tower: A circular, square, or octagonal vertical structure higher than the surrounding structure that is usually part of an existing building and is created either for extra defense or for a specific purpose such as a clock or a bell tower. Example: Queen's Square Retirement Residence – clock tower	
Turret: a small tower that projects from the wall of a building. Example: Water Street	
Rose Window: a circular window with ornamental tracery radiating from the centre. Example: 7 Queens Square, Central Presbyterian Church	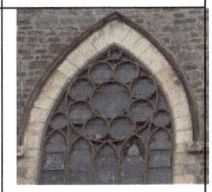
Vergeboards: also called bargeboards – hang from the projecting end of a roof and are often elaborately carved and ornamented.	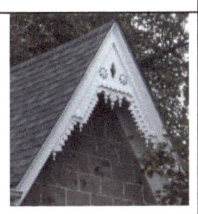
Window Hood: A **hood** is the piece found above window openings, usually of an ornate design, and covers the top third of the opening. Hoods are commonly placed above arched or curved openings on both windows and doors. Example: Water Street	

Galt's Building Styles

Beaux Arts: Promoters of this style sought to express the classical principles on a grand and imposing scale. Many of the Beaux Arts buildings were banks, post offices, and railway stations. The Ontario Beaux Arts style is eclectic mixing elements of Classical, Renaissance and Baroque. Often the designs have a temple-like façade, pedimented porticos, balustrades, capitals in many styles Example: Galt Public Library, Water Street	
Edwardian, 1900-1930 – This style bridges the ornate and elaborate styles of the Victorian era and the simplified styles of the 20th century. Balanced facades, simple roof lines, dormer windows, large front porches, and smooth brick surfaces are its characteristics. Example: 60 Grand Avenue North	
Gothic Revival, 1830-1890 – These decorative buildings have sharply-pitched gables with highly detailed vergeboards, pointed-arch window openings, and dichromatic brickwork. It is a common style in Ontario. Example: 24 South Square	
Italianate, 1850-1900 – It has wide-bracketed eaves, belvederes, wrap-around verandahs. Example: 222 Main Street	

Regency Cottage, 1830-1860 – This style originated in England in 1815 and spread to Ontario later in the 19th century as British officers retired to Canada. It is a modest one-storey house with a low-pitched hip roof and has a symmetrical front façade. Example: 91 Shade Street	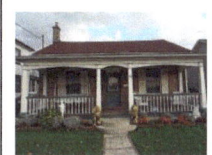
Second Empire, 1860-1880 – The mansard roof is the most noteworthy feature of this style and is evidence of the French origins. Projecting central towers and one or two-storey bays can also be present. Example: Queen's Square Terrace Retirement Residence	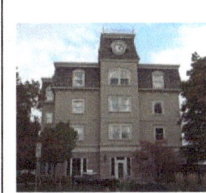
Tudor Revival – exposed timbers with stucco infill, multi-paned windows. Example: 39 Grand Avenue South	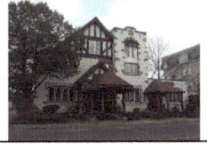